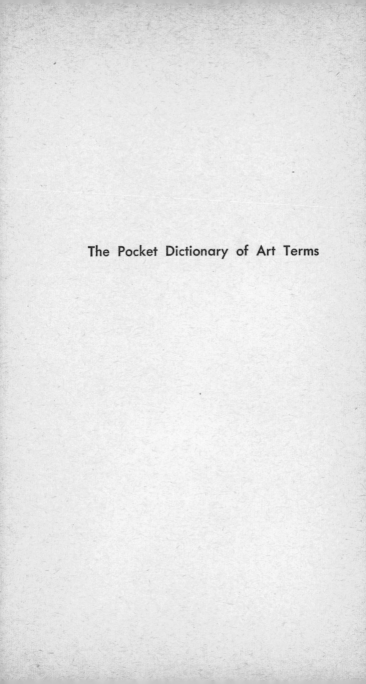

The Pocket Dictionary of Art Terms

The Pocket Dictionary of Art Terms

Edited by Mervyn Levy

NEW YORK GRAPHIC SOCIETY

ARTS & BOOKS

Greenwich, Connecticut

INTRODUCTION

A Dictionary of art terms—indeed any technical glossary—should combine two main functions. It should, first of all, provide immediate and compact basic definitions of terms and expressions relative to a specific field, while at the same time stimulating the enquirer to pursue through further reading and, in this case, the study of living works of art, more detailed and exhaustive researches into the origin and nature of the terms and expressions included.

A Dictionary, necessarily, can only deal with such matters in the most general sense. The author hopes therefore that the reader of this book will not only be encouraged to pursue in detail the lines of research indicated, and to follow up the works of such writers as are referred to from time to time (e.g. Bernard Berenson, R. G. Collingwood, and Sir Herbert Read), but that he will be persuaded to check for himself, against original works of art, the exact nature of those expressions, such as *matière, impasto,* and *patina,* that are directly concerned with the physical character and qualities of painting, and sculpture. Only thus will the meaning of terminology acquire real life, and significance.

Used in this way a Dictionary is something more than a means of explaining terminology; it is the key to a complete understanding of the physical, philosophic, and psychological foundations of a special field of study, in this case, that of art.

MERVYN LEVY

A

ABBOZZO

The underpainting of an oil painting, either in monochrome or colour. Sometimes called *Bozzo* or *Dead-colouring*.

ABSTRACTIONISM (ABSTRACT ART)
(Non-figurative or non-objective art)

In the purest sense abstract art consists of the creation and organization of shapes, forms, and colours which have no counterparts in nature. Thus a creative variation on any of the themes of nature (e.g. the cubist still life in which recognisable objects appear) is not strictly speaking an abstraction. Wassily Kandinsky (1866–1944) and Kasimir Malevich (1878–1935) were pioneers of modern abstract painting. Abstract conceptions of an

9

un-organic geometrical type were typical of the work of the Dutch Group, known as 'De Stijl' (Style) formed in 1917 (see below) by Theo Van Doesberg in association with Piet Mondrian, perhaps the most purely abstract of all painters in this vein. Abstractionism is based on the complete rejection of known objects and the creation of a pictorial dimension in which the artist fashions entirely new visual data, without associations or precedents. The principle applies equally to painting or sculpture. See *Action Painting* and *Tachisme*.

ABSTRACT–EXPRESSIONISM

An alternative term for *action painting* (q.v.).

ACADEMIC

In painting, sculpture, etc., conforming to established conventions; in the manner of an approved tradition; not original.

ACADEMY

Originally the garden near Athens where Plato taught. More generally, a place of study. The first academies of art included the Guild of St. Luke founded at Venice in 1345, the School at Bologna founded about 1575 by Denis Calvaert (1540–1619), and the Academy, also at Bologna, opened by the Carracci a little later. In 1648 the Royal Academy of Fine Arts was founded in Paris, and the English Royal Academy with its teaching schools was established in 1768.

ACANTHUS

In Greek and Roman architecture, the conventional representation of the leaf of the acanthus plant. The sculptured leaf peculiar to the Corinthian capital.

ACROLITH

Archaic Greek statue, with head and extremities of marble or stone, and body of wood. The bodies were sometimes gilded or overlaid with gold.

ACROPOLIS

The citadel, or elevated part of a Greek city. Best known is the acropolis at Athens, now famous for the ruins of temples built there in the days of the Athenian empire.

ACTION PAINTING

A method of producing relatively fortuitous and completely abstract effects in paint, pioneered by the American artist Jackson Pollock (1912–1956). The essence of the method is contained in the violent action of splashing, slapping, dribbling, or otherwise applying paint to a surface, frequently laid flat, so that the initial effects are wholly accidental. The resulting fortuitous random patterns and designs are then permitted to suggest to the painter the basis of a more consciously controlled completion. But the basic impact is necessarily accidental. The method is also called *abstract-expressionism* because of the explosive and emotional nature of the painter's initial sortie over the painting surface.

ADVANCING COLOUR

A strong, usually unadulterated colour, which appears to advance to the front of a picture.

AERIAL PERSPECTIVE

The creation of the effect of distance on a flat surface, obtained by using colder and paler colours for the more distant features, such as a range of hills. Theoretically, objects tend to become colder and paler as they become more distant and as their hues are modified by the conditions of light, air and distance.

AESTHETICS

That branch of philosophy which deals with the psycho-physiological nature of the beautiful in relation to the work of art, its perception and appreciation. Theoretically, the purpose of aesthetics is the establishing of laws, criteria, etc. which will facilitate the appreciation and understanding of works of art.

'AESTHETIC MOMENT, THE'

According to Bernard Berenson, 'the aesthetic moment' is 'that flitting instant, so brief as to be almost timeless, when the spectator is at one with the work of art. He ceases to be his ordinary self, and the picture or building, statue, landscape or aesthetic actuality is no longer outside himself. The two become one entity.' (Compare *Empathy*.)

AESTHETIC MOVEMENT

An English late nineteenth century movement which advocated a philosophy of 'art for art's sake.' It was largely a type of art appreciation, the excesses of which were satirized in W. S. Gilbert's opera *Patience*. The chief apostles of the movement were Walter Pater (1839–94) and Oscar Wilde (1856–1900).

ALLA PRIMA

Direct painting. The completion of a painting by a single application of pigments, in contrast to a painting which is completed in stages by the application of successive layers of pigments; such as glazing and scumbling over an underpainting.

ALTAR-PIECE

A painting behind and above an altar. A complete altar-piece consists of *Triptych* and *Predella* (q.v.).

ALTO-RELIEVO

Sculpture in high relief.

'AMUSEMENT ART'

One of the types of art categorised by R. G. Colling-
wood in his *Principles of Art*. 'If an artifact is designed
to stimulate a certain emotion, and if this emotion is
intended not for discharge into the occupations of ordi-
nary life, but for enjoyment as something of value in
itself, the function of the artifact is to amuse or enter-
tain.' Collingwood draws the distinction between 'art
proper,' which is 'life-enhancing' (Berenson) and 'amuse-
ment art' which is degraded. As an example of the crud-
est and most brutal form of 'amusement art,' Colling-
wood cites 'pornography' which he qualifies as an 'art'
based on a sexual motive 'which is essentially an ap-
peal to the sexual emotions of the audience, not in or-
der to stimulate these emotions for actual commerce
between the sexes, but in order to provide them with
make-believe objects and thus divert them from their
practical goal in the interest of amusement.' The crite-
rion is especially applicable to films and books of a cer-
tain kind.

ANALYTICAL CUBISM

The first stage in the practice of Cubism (see *Cubism*).
Natural forms are analysed and reduced to their basic
geometric constituents. The precedent for this practise is
the theory expounded in one of Cézanne's letters to
Emile Bernard, dated 1904, in which he wrote, 'Treat
everything in nature in terms of the cylinder, the sphere
and the cone.'

ANAMORPHOSIS

A distorted painting which appears normal when viewed
from the side. A form of 'trick' painting, fashionable in
the sixteenth and seventeenth centuries.

APOTROPAIC EYE

In Greek art, the representation of the human eye on objects (e.g. the prow of a boat), as a talisman against evil.

APPLIED ART

The application of aesthetic principles in the fields of applied design. Design in industry: e.g. the design of posters, furniture, kitchenware, motorcars, etc.

APPLIQUÉ

A pattern, or picture, formed by laying various materials, usually on a fabric ground. Especially suitable for dressmaking and needlework.

AQUARELLE

A drawing or print which has been coloured with transparent water colour washes.

AQUATINT

A method of engraving which, like etching, involves the use of a mordant acid for biting a metal plate, but differing in that aquatint is used to render tonal instead of linear effects.

ARABESQUE

Decoration in colour, or low relief, composed of flowing patterns of flowers, leaves, branches, scroll-work, etc. fancifully intertwined.

ARCHAIC: ARCHAISM

Strictly the styles of antiquity. Also the retention, or imitation of what is ancient, antique, for special purposes. E.g. Paul Delvaux's adaption of classical architecture as a background for his version of Surrealism; the forms of Picasso's Classical Period.

ARCHITECTONIC
Pertaining to the science of architecture and the application of architectural principles as a constructive element in design.

ARCHITRAVE
The main beam resting directly on the abacus, usually a square slab topping the capital of a column. Also the various parts surrounding a doorway or window.

ARMATURE
The frame work, usually of metal, used by the sculptor, as a foundation, or skeleton, for clay modelling.

ART NOUVEAU
Literally, new art. In Germany called *Jungenstil*. The term applies especially to the work of painters, illustrators and designers during the late 1890's and the early 1900's, and is characterised by the use of flowing lines and ornament based on flowers, leaves, branches, and the like. Strongly marked the architecture and interior decoration of van de Velde in Holland. In England the applied art of William Morris and the illustrations of Aubrey Beardsley, and in America the architectural ornament of Louis Sullivan, are expressive of the idiom.

ART THERAPY
The practise of free expression painting, modelling, etc. as a curative activity. Painting, and other forms of creative art, as practised by patients in mental hospitals, sanatoria, etc. as a means of relieving psychological tension, as part of a scheme of occupational activities, as relaxation, or for other medical-psychological reasons.

ARTIFACT

The work of art; the making of which, according to R. G. Collingwood, consists of (a) the creative plan, (b) the imposition of that plan on certain matter, through skill or craft, or technique; the transformation of pre-existing material. It has a special meaning in archaeology, referring to the product of prehistoric workmanship as distinct from a product of nature, e.g. a flint, and is sometimes used contemptuously to indicate a rudimentary art.

ARTISTIC ANATOMY

A simplified form of anatomy designed for the artist. The study of the skeleton, and of the surface muscles of the body, as an aid to the accurate representation of the figure in painting and sculpture. Visible musculature

ASHCAN SCHOOL

A group of early twentieth century American painters specialising in realistic portrayals of city life and scenes. The original group, under the leadership of Robert Henri and including George B. Luks, William J. Glackens and Everett Shinn, was first active in Philadelphia in the 1890's. At the turn of the century the group moved to New York and became known as the New York Realists. The origin of the designation 'Ashcan' is in doubt, but it certainly stems from the absorption with subject matter drawn from the seamier side of city life. The original group were also known as *The Eight* (q.v.).

ASYMMETRY

Beauty resulting from aesthetic irregularity. Aesthetic disproportion in the physical organisation of subject matter. The converse of *Symmetry* (q.v.).

ATELIER
A workshop; a painter's or sculptor's studio.

ATLANTES
Carved male figures sometimes used instead of columns to support an entablature.

ATMOSPHERIC COLOUR
Colour modified by atmosphere; the conditions of light, air, distance.

AUREOLE
A halo; an alternative term for *Nimbus* (q.v.).

AUTOMATISM
In relation to surrealism, the practise of automatic drawing or painting. The free, uncontrolled movement of hand and pencil, or brush, etc. without conscious direction on the part of the artist.

AUTORITRATTO
A self-portrait.

B

BAMBOCCIATA

A term for grotesque and rustic subjects, derived from 'Il Bamboccio' the nickname of Pieter Van Laer, a seventeenth century Dutch painter notable for such subjects.

BAPHOMETS

Small, grotesque stone figures of coarse workmanship, covered with symbols, such as the sun, moon, flames, T-shaped crosses, and meaningless Greek, Latin and Arabic characters. At one time believed to be the symbol or idol which the Knights Templars were accused of worshipping in their secret rites. The Baphomets are now regarded as forgeries dating from the time of the Gothic revival, when the Knights Templars were a favourite sub-

ject of literature. The name Baphomet is presumably a corruption of Mahomet.

BARBIZON SCHOOL

From the village of that name on the outskirts of the Forest of Fontainebleau. The object of the group of French painters who lived and worked in the locality from the 1830's on was to portray nature not as a mere backcloth for classical subjects, but as a living, dynamic force in her own right. The trend was influenced by the rise of English landscape painting, and in particular by the art of John Constable (1776–1837). Leaders of the School included Camille Corot, Jean Francois Millet, Theodore Rousseau and Charles Daubigny. In many respects the philosophy of the Barbizon painters anticipated the emergence of *Impressionism* (q.v.).

BAROQUE

The style of the art of the Counter Reformation, and a reaction from the classicism of the Renaissance. From the Spanish, *barrueco,* and the Portuguese, *barroco,* meaning a large, rough, irregular pearl, of the kind used in the florid jewellery of the period. The stylistic tendencies which accompanied the Counter Reformation of the Jesuits, characterised by a dramatic and theatrical conception in painting and sculpture, and a bizarre, fantastic, and grotesque use of ornament and decoration in architecture. The introduction of the twisted column was an innovation of the Baroque. The style was prevalent in the seventeenth and eighteenth centuries on the Continent. During this period thousands of artists were employed to paint altar-pieces, and great turbulent murals on walls and ceilings, depicting with dramatic intensity, scenes of martyrdom and terror, damnation and ecstasy, designed to excite religious fervour and exaltation in the spectator. Michelangelo is usually considered to be the father of the Baroque style (in

painting and architecture especially, e.g. the tomb of Giuliano de'Medici in S. Lorenzo, Florence) although the strength of his conception is debased in the Baroque period proper by the introduction of crude theatricalism and forced sentimentality. Among the leading exponents of the Baroque style were Giovanni Bernini (1598–1680) architect, sculptor and painter, designer of the colonnade surrounding the piazza outside St. Peter's, Rome; Jusepe Ribera (1591–1656) and Bartolomé Murillo (1617–1682). In Flanders Rubens (1577–1640) evolved his own version of the Baroque.

BAS-RELIEF (BASSO-RILIEVO)

Sculpture in low relief.

BASILICA

A type of public building common to ancient Rome. A large, roofed hut, flanked by columns, usually with an aisle on each side. The type was adopted by the early Christians for their churches.

BAUHAUS, THE

A German educational institution and research centre for the training of architects, artists, industrial designers, etc. Founded in Weimar in 1919 by Walter Gropius and subsequently established at Dessau. Closed by Hitler. The Bauhaus doctrine maintained that there should be no division between architecture, the fine arts, and the design of useful objects produced industrially as well as by hand. The Bauhaus strove for the closest connection between art, science and technology.

BIEDERMEIER

Term applied to certain forms of German art, c. 1830–1860, banal or sentimental in character, and reflecting

a Philistine, middle-class outlook. It is still used with disparaging implication.

BINDER

Uniting as glue; causing adhesion. Vehicles such as oil which cause particles of powdered colour to remain fixed to the painting surface are described as agglutinants.

BISCUIT

Pottery, porcelain, etc. after baking, but before glazing.

BISTRE

A brown impermanent pigment prepared from soot. Often used by old master draughtsmen.

BITUMEN

Mineral pitch, asphaltum. When used as a pigment, such as bitumen brown, it causes severe cracking. It possesses poor drying power, and a tendency to soften in higher temperatures. Sometimes used by Rembrandt as a glaze, and as such did no damage. Its use is not now advised under any circumstances.

BLEEDING THROUGH

A correction which an artist has made during the early stages of an oil painting, and which becomes visible after the passage of time. Pigments ground in oil tend to become transparent with time, and this is the usual cause of bleeding.

BLISTERS

One of the chief diseases to which oil paintings are prone. Due to such causes as moisture or damp attacking the canvas from the back.

BLOOM

The opaque film which sometimes forms over the surface of an oil painting. A progressive disease which commences as a bluish veil, passing through grey and yellow stages, to a final state of blackness.

BLUE RIDER (DER BLAUE REITER)

The name of a group of German Expressionist painters, founded at Munich in 1911. (See *Expressionism*.) The group, which included Franz Marc, Paul Klee and Wassily Kandinsky formed the abstract-expressionist branch of the movement.

'BLUING'

The 'turning blue' of certain picture varnishes, due in all probability to moisture in the varnish or on the picture surface.

BODY COLOURS

Pigments, whether oils, or water colours, which possess 'body' or opacity, as opposed to those pigments which are transparent.

BOSS

In architecture, the stone projection, or block, at the intersecting-point of the vault ribs. Frequently carved with grotesque portraits, symbols, designs, etc.

BOTTEGA

Studio, or atelier. Generally used to describe an Italian painter's workshop, where pictures were not only painted, and apprentices taught, but where pictures for sale were displayed.

BOULLE-WORK

A process of inlaying ebony with silver, brass, mother-of-pearl, tortoise-shell, etc. invented by the French cabinet-maker André Boulle (1642–1723).

BRAVURA

Spirited brushwork.

BRIDGE THE (DIE BRUCKE)

A group of Expressionist painters. See *Expressionism* below.

BROKEN COLOUR

Colour which is varied by the introduction of other colours. Strictly speaking, an inevitable condition of painting, since each colour is both affected by, and in turn, affects, the colours in proximity.

BRONZE DISEASE

The light green spots which disfigure ancient bronzes, and which are caused by the presence of salts that have impregnated the surface of the metal.

BRONZING

The colouring of plaster casts to represent bronze, by painting them with a mixture of shellac varnish and Vandyke brown, or with green powder colour.

BUON FRESCO (TRUE FRESCO)

The method of painting on walls in pigments mixed with water, and applied to damp plaster. The pigment penetrates the wet plaster and is held by the chemical action of the lime which is present, and converted by the action of the air into a carbonate, which acts as a binder.

It was the method employed in painting the frescoes in the Palace at Knossos, the frescoes in Pompeii, the wall paintings of the Middle Ages, and by Italian mural painters of the fifteenth and sixteenth centuries.

BURR

The ridge of metal ploughed up by the graver or burin during the process of engraving. In a line engraving the burr is removed so as to leave a clean line; in 'drypoint' it is left on the plate, and imparts to the print the soft, melting quality, which is characteristic of this technique.

BUTTONS

Small pieces of wood which are glued in place to restore splits in a wooden painting support, such as a panel.

BYZANTINE ART

Art of the eastern Roman Empire associated with the reign of the Emperor Justinian (483–565 A.D.) and the style of pictorial representation established by the mosaics at St. Sophia, Constantinople, the great church built by the Emperor. For over a thousand years the influence of the Byzantine style was extended virtually over the whole of Europe. In the form of icon painting it lasted until the 17th century, while traces of its influence can be seen in the paintings of El Greco (c. 1545–1614).

C

CABINET PICTURE
An alternative term for *Easel-picture* (q.v.) or table.

CALLIGRAPHY
Descriptive of beautiful handwriting; the term has an extended meaning, being applied to the characteristic stroke of an artist's brush or pen.

CAMAIEU
Painting in monochrome. A monochromatic painting of a cameo, or bas-relief. A style of painting which was practised as long ago as the time of Zeuxis. When the key colour is grey, such painting is known as *Grisaille* (see below). When the key colour is of a yellow nature, it is known as *Cirage*.

CAMERA LUCIDA

A nineteenth century development of the Camera Obscura in which a prism is used instead of a lens for projecting the image onto the drawing surface.

CAMERA OBSCURA

An apparatus for projecting a diminished reproduction of a view onto a piece of material, so that it can be traced. Antonio Canaletto (1697–1768) is reputed to have used such a device, and Thomas Girtin (1775–1802) did so for a series of etchings of architectural subjects.

CAMPANILE

A bell-tower, near, or attached to, churches or town halls in Italy, such as the Tower of Pisa, or the Campanile at Florence designed by Giotto (1266?–1337).

CAPITAL

In architecture, the head of a pillar, or column.

CAPOSCUOLA

The Master of a School of Painting.

CAPRICCIO

Generally speaking, a painting of an imaginary architectural subject. Imaginary capricci of known buildings, or purely fabricated groups, were particularly popular in the eighteenth century. Canaletto (1697–1768) was a painter of capriccii.

CARICATURE

A grotesque representation of a person, or thing, based on the over-emphasis or exaggeration of characteristic traits, etc. A satirical, or ridiculous, representation.

CARTOCCIO

The little scroll, or plate, in Italian paintings upon which is inscribed the name of an artist, or the identity of a portrait.

CARTOON

A preliminary sketch, or detailed drawing, for a painting, mural, etc. either to scale, or actual size. The design is transferred from the paper to the working surface, such as a panel, canvas, or wall by *squaring* or *pouncing* (q.v.). The term is also used to describe a comic drawing, or an animated film based on a succession of comic or grotesque drawings.

CARTOUCHE

An architectural ornament in the form of a scroll; e.g. volute of Ionic capital. Tablet imitating scroll with rolled-up ends. Used as pure ornament, or bearing inscription such as armorial symbols. Oval ring containing hieroglyphic names and titles of Egyptian Kings, etc.

CARYATID

A draped female figure serving as an architectural column.

CASSONE PAINTING

The pictures used to decorate the sides of an Italian marriage-chest (*cassone*). The most common subjects were scriptural, chivalrous, mythological and heraldic.

CASTING

In sculpture, the process of duplicating a clay original, in plaster, or metal (such as bronze) by the use of a mould.

CATACOMBS

Subterranean tombs in Rome, decorated with paintings, where the early Christians buried their dead.

CAVALLERESCO PAINTING

A painting of a romantic or chivalrous scene.

CAVE PAINTING (PREHISTORIC PAINTING)

The art produced in the form of paintings on the walls of caves from the beginning of the Old Stone Age to the end of the New Stone Age around 3,000 B.C. The whole period covers a span of some 200,000 years. The Palaeolithic cave paintings at Altamira (Spain) and those at Lascaux (France) are believed to date between 40,000 and 10,000 B.C.

CAVO-RILIEVO

Hollow relief.

CENACOLO

A painting portraying the Last Supper.

CERA COLLA

A wax emulsion used by Byzantine painters. When mixed with a proportion of glue-water it made an intermediate varnish for tempera painting.

CERAGRAPHY

An alternative term for *Encaustic* (q.v.). Also, any sort of painting on Wax.

CHAMPLEVÉ ENAMEL

A method of decorating metal, usually copper, by hollowing out parts of the background of the design, and filling these with coloured, vitreous pastes (enamels).

CHASING

A method of ornamenting metal surfaces, such as gold or silver, by a process of embossing, hollowing, or engraving with steel tools.

CHASSIS

French term for 'Stretcher.' The wooden frame on which a canvas is stretched or the revolving stand on which a modelling armature is placed.

CHIAROSCURO

The treatment of light and shade in painting. Rembrandt is the great master of chiaroscuro. Earlier the school of Italian chiaroscurists led by Caravaggio (c. 1569–1609) exerted much influence.

CHINOISERIE

A French term, referring mainly to the eighteenth century application of Chinese motifs of design in ceramics, wallpaper, furniture and decoration in general. Associated with the Rococo style of the period.

CINQUECENTO

The sixteenth century in Italian art.

CLASSICAL-ABSTRACTION

The creation of carefully controlled, disciplined, abstract painting (or sculpture). As opposed to *Action Painting* and *Tachisme*. E.g. the art of Malevich, Mondrian, and Ben Nicholson, and in sculpture, Barbara Hepworth.

CLASSICAL ORDERS

The five Orders of Architecture, viz. Doric, Ionic, Corinthian, Tuscan and Composite.

CLASSICISM

In art, the opposite of Romanticism. That kind of art which emphasizes those qualities considered to be characteristic of the Greek or Roman style, and conception, i.e. reason, objectivity, discipline, restraint, order, etc. The classical style is sometimes defined as an amalgam of 'simplicity, harmony and proportion.'

CLAUDE GLASS

An aid to the selection of suitable material for a landscape composition. The Claude Glass (so called because the painter Claude Lorrain (1600–82) is said to have used one) is a black, convex glass, which reflects a view in miniature, largely eliminating colour and detail, so enabling its suitability as a subject to be more easily judged. Seldom used nowadays, but frequently spoken of in accounts of seventeenth, eighteenth, and nineteenth century painting.

CLOISONNÉ

A method of decorating metal, possibly Byzantine in origin, which consists of constructing a design on a metal or porcelain ground, in little fences of metal, and filling the spaces with variously coloured vitreous pastes (enamels). Also, the ware thus decorated.

COLLAGE

An extension of the technique of *Papiers Collés*, developed by the Surrealist painter Max Ernst. A collage is a picture or design, composed of such elements as coloured papers, newsprint, railway tickets, photographs, engravings, pieces of string, hair, fabric, etc. pasted onto a background. The technique was widely employed by the Dadaists as a means of relating disparate fragments of different materials.

COLORIMETER
An instrument for measuring the intensity of colour.

COLOUR
Colour has three qualities:—
1. *Hue*—The actual colour itself, e.g. red, yellow, blue, etc.
2. *Chroma*—The relative brilliance or *intensity* of a colour, e.g. *bright* green or *dull* green.
3. *Value*—The modification of a colour by (a) light, (b) air, (c) distance.

COLOUR CIRCLE
An arrangement of the colours of the spectrum in the segments of a circle, one half of which contains the warm colours, and the other the cool colours. Complementary colours can be seen opposite one another and if the disc is made to revolve rapidly, the eye experiences the sensation that the disc is white. This is one proof that white light is composed of the colours of the spectrum.

COLOUR PERSPECTIVE
An alternative term for *Aerial Perspective* (see above).

COLOUR UNITY
A picture which is in harmony because the main colours employed are all to be found on the same side, or in the same segment, of the colour circle.

COLOURED GREY
A grey which is made by the mixing of complementaries, such as red and green, blue and orange, etc.

COMPLEMENTARY COLOURS

Colours which exhibit the maximum contrast. They appear opposite one another on the colour circle (e.g. red opposite green). When mixed as pigments they tend towards the production of 'coloured greys.' Colours are said to be complementary if, when mixed, they neutralize each other.

COMPOSITE COLOUR

A colour composed from the mixture of two or more hues, e.g. orange made by the mixture of red and yellow.

COMPOSITION

The organisation of the physical elements in a work of art. The arrangement of shapes, forms, masses, etc.

CONSTRUCTIVISM

The creation of three-dimensional abstracts by the use of any of the materials used in modern technics, e.g. wire, iron, or wood. Leading constructivist artists include such contemporaries as Antoine Pevsner, Nahum Gabo and Moholy Nagy. The first Constructivist Exhibition was held in Moscow in 1920.

CONTENT

The subject matter of a work of art, as distinct from the form (see *Significant Form*) in which it is expressed.

CONTOUR

The outline or external boundary of a form. The illusion of a line enclosing form. An artist may use contour as an element of grace, subtlety, strength, rhythm.

CONTRAPPOSTO

The quality of contrast in painting; the contrast or opposition of masses, movements, rhythms, etc.

CONTRASTING COLOURS

When placed side by side, complementary colours (e.g. red and green, orange and blue, yellow and purple) appear intensified.

CONVERSATION PIECE

A set of portraits, usually less than life-size, linked by a theme, such as a family setting, and grouped unconventionally *as though in conversation* or as a meeting in the normal course of everyday life.

COOL COLOURS

Colours of a cool hue, such as green and blue, which appear opposite warm colours, such as yellow and orange, on a colour circle.

COPTIC PAINTING

A distinctive Early Christian style of painting common in Egypt between the fourth and seventh century. Originating in the realistic style of the Fayum mummy portraits (see *Fayum portrait*) the coptic style proper abandoned the three-dimensional qualities of Fayum art for the sake of flat pattern, decorative and ornamental features. Generally speaking, the aesthetic style of the Egyptian Coptic Church.

CORING

A method of strengthening a wooden panel which has been attacked by worm, or rot. The process consists of removing the damaged parts, and then reinforcing the thinned panel by gluing to it one piece of wood with the grain running at right angles, and another piece with the grain running the same way as that of the original panel. The principle is that of three-ply wood.

CORPORATION PIECE

A set of life-sized portraits, such as a group of civic dignitaries, members of a guild, or corporation.

COSMATI, THE

A school of Roman mosaic workers who were active from the twelfth to the fourteenth century. They specialized in Church pavements inlaid with marbles cut from ancient Roman materials and cubes of coloured glass.

COSMORAMA

A peep-show or exhibition of paintings of views of different parts of the world, seen through a lens.

COUNTERPROOFS

Forged drawings produced by a process of damping and pressing. Counterproofing was originally a method of reproducing drawings.

CRACKLE

In pottery, the calculated fracturing of the glaze during firing to produce a particular effect.

CRADLING

A method of correcting the warping in a wooden painting surface by a process of gluing wooden slats to the back of the panel.

CRAQUELURE OR CRACKING

A common defect of oil paintings due to a variety of causes, such as the state of the ground and priming, the misuse of certain pigments, the misuse of certain vehicles and premature varnishing.

CREDENZA PAINTING
A decorative painting on a buffet or sideboard.

CROSS—HATCHING
The crossing at various angles of the lines, usually in pen and ink, with which an artist constructs his areas of shadow or modelling. A similar technique was often used by medieval fresco and tempera painters.

CUBISM
The reaction against the diffuse, formless character of Impressionism led by Picasso and Braque, and initiated in 1908 when certain elements in a work by Braque were referred to by the critic, Louis Vauxcelles, as 'little cubes.' Cubism, which took up Cézanne's search for basic, geometric elements—for the inherent construction, the bones of nature—aimed first of all at their realisation through a process of breaking down, and taking apart the forms of nature (analytical cubism) and secondly, at an imaginative reorganisation of these geometric elements in various contexts (*Synthetic Cubism*). The final aim of Cubism was the realisation of new combinations of fundamental forms. Colour therefore plays little part in the creation of Cubist painting, which was concerned primarily with the liberation of form, whereas Impressionism was chiefly concerned with the liberation of colour. The major cubist achievements belong to the period, approximately, 1908–1920 and besides Picasso and Braque, the painters Fernand Léger and Juan Gris were notable contributors to the movement.

D

DADAISM

A movement in painting and the other arts, of cynicism,
bitterness, and ridicule engendered by the collapse of
social and moral values which developed during the
war of 1914–18. Dadaism was founded in 1916 by
Tristan Tzara in Zurich when he fortuitously put his fin-
ger in a dictionary on the word Dada, meaning 'hobby-
horse.' The spirit of Dada is pure nihilism, a negation
of all standards, values, and conventions, as a protest
against the collapse of social values and as a reaction
against all established traditions of logic, art, etc. The
battle cries of the Dadaists included 'To hell with
Cézanne!' and 'Assassiner la peinture!' Typical Dadaist
exhibits were such items as a reproduction of the Mona
Lisa with a moustache attached, and the celebrated

'Fountain'—a urinal. During the years 1917–20 the Dadaists held a number of riotous exhibitions in various European cities, one of which was closed by the police. Dadaism was a crude forerunner of *Surrealism* (q.v.).

DARKENING

One of the diseases of oil paintings, the chief causes of which are, canvas which has been treated with seal oil during the manufacturing process, the use of primings with an insufficiency of body-colour, the use of dark primings, the use of too much oil as a vehicle, the storing of paintings in dark rooms, certain climatic and atmospheric attacks upon the back of a canvas.

DECADENT MOVEMENT

A critical and disparaging term sometimes used loosely as a synonym for the *Aesthetic Movement* (see above) but more particularly the assertion by certain nineteenth century writers and painters, e.g. Aubrey Beardsley and Ernest Dowson, of the right to extract aesthetic value from the study of weird or extravagant subject matter of exaggerated romantic origin. More generally speaking, decadence in art means the decline, or falling away which succeeds the culmination of a creative period.

DECORATED STYLE

The second phase of English Gothic architecture, following Early English and preceding the Perpendicular style. The period lasts from about 1300 to 1400.

DESIGN

The plan or general conception of a work of art. Applied in a special sense since the 19th century to the production of attractive and well-formed objects of use.

DE STIJL (THE STYLE)

A Dutch movement primarily concerned with functionalism and the integration of painting and sculpture with architecture and industrial design. Originated by Theo Van Doesburg (1883–1931) and Piet Mondrian (1872–1944) in 1917, the creed of *De Stijl* was utter simplicity. The basic form was the rectangle; the basic colours, the primaries red, blue, and yellow. This simplification was applied alike to the arts of painting, sculpture, and every form of applied design: e.g. posters, typography, furniture design, and even architecture. Also called Neo-Plasticism.

DIABLERIE

A picture representing the infernal powers.

DIMINISHING GLASS

An alternative name for *Reducing Glass* (q.v.).

DIORAMA

A painting, usually on cotton, on the back of which are painted other things. When the painting is lit from the front only the picture on the front surface is visible; when lit from behind the details on the reverse side can be seen. By manipulation of the direction, colour and intensity of the lighting, the appearance of the painting can be changed. With this device it is also possible to create the appearance of such natural effects as sunrise. The Diorama was the invention in 1822 of Daguerre and Bouton. Now, applied to scenes painted as back drops in natural history displays.

DIPTYCH

An altar-piece consisting of two hinged panels, e.g. 'The Wilton Diptych' National Gallery, London.

DIRECT PAINTING

An alternative term for *Alla Prima* (see above).

DISTEMPER

Paint prepared from water and size and used for large scale decorative or mural painting. Not to be confused with true fresco.

DISTORTION

In art, any deviation from the normal, objective shape, form, and general appearance of things. Distortion is virtually a condition of all painting, sculpture, etc., since the vision and conception of the artist is controlled by *subjective* (immeasurable) as much as by *objective* (measurable) circumstances.

The degree of distortion (which is infinitely variable) can range from the moderate distortions of El Greco, to the acute distortions of modern Expressionist painting.

DIVISIONISM

An alternative term for *Pointillism* (q.v.).

DOSSALE PAINTING

The painting on an altar-piece. Also known as *Paliotto Painting*.

DOWELS

Small pieces of wood which are inset and glued into place to restore splits in a wooden painting surface, such as a panel.

DRAGGING

A method of applying pigment with little or no vehicle by dragging it lightly over the tacky surface of a painting, in order to produce a broken effect.

DRIER

See *Siccative*.

DRYPOINT

A method of Engraving in which the line is incised directly into the plate, with a sharp instrument. As distinct from an etched line which is bitten. Drypoint prints are characterised by the softness of their appearance. This is due to the collection of ink by the *Burr* (see above).

DUECENTO

The thirteenth century in Italian art.

E

EARLY CHRISTIAN PAINTING

Usually considered to mean the mosaics, frescoes, panel paintings and manuscripts produced by artists during the first centuries of the Christian era. The earliest Christian paintings were those carried out in the Catacombs of Rome. These were followed by the mosaics of Byzantium, and later by medieval panel and fresco painting.

EARLY ENGLISH STYLE

In architecture the name given by Thomas Rickman (1776–1841) to the first of the three periods of English Gothic. It covers the period from about 1190 to about 1280 and is characterised by lancet-windows without mullins, frequently grouped in threes, fives or sevens; the pointed arch; pillars of stone centres enclosed by

shafts of black marble; dog-tooth ornament, etc. Salisbury Cathedral is virtually Early English.

EARTH COLOURS

Those pigments, such as yellow ochre, terra verte, and umber, which are obtained by mining. They exist in veins and pockets and owe their colour to the presence of compounds of iron, and closely associated metals like manganese.

EASEL-PICTURE

An alternative name for cabinet-picture, or table. Any relatively small, transportable painting, in contrast especially to mural painting.

ECLECTICISM

A theory taught by the Carracci at their Academy in Bologna. Lodovico C. (1555–1619) and his cousins Agostino C. (1557–1602) and Annibale C. (1556–1609) founded the Eclectic School of Painting, whose work was based on the theory that the painter should choose what he considered to be the respective merits of various schools and masters, and combine these qualities in his own work. In a more general sense, any type of painting which borrows freely from a variety of sources.

ÉCORCHÉ

Flayed figure. An anatomical painting or sculpture with skin removed to display the muscular construction of the body.

EIGHT, THE

A group of early twentieth century American painters which came into being as the result of the rejection of a canvas by George Luks from the National Academy in 1907. The group, eight members in strength (George

Luks, Robert Henri, John Sloan, William Glackens, Everett Shinn, Ernest Lawson, Arthur Davies and Maurice Prendergast) held their first Exhibition at the MacBeth Gallery in 1907. The members specialised in painting matter-of-fact, everyday subjects, and because of this interest were also called the *Ashcan School* (see above).

EMBOSSING

Carving, moulding or stamping of any sort, which throws figures, symbols, or designs into relief.

EMPATHY

A word of Greek derivation used to describe the Theory of EINFÜHLUNG (Ger.). Literally, EINFÜHLUNG means 'feeling into' and the theory proposes the 'feeling' or projection of personality *into* the object of contemplation, i.e. the work of art. The result of this 'feeling into' is the creation in the spectator of an instantaneous emotional identification of the 'self' with the work of art. The word EINFÜHLUNG has been translated as 'empathy' on the analogy of 'sympathy'; just as 'sympathy' means feeling *with*, so 'empathy' means feeling *into*.

EMULSION

A medium, or vehicle, which consists of water and oil; those containing emulsifying agents like albumen, casein, egg, gum arabic, size, wax, etc.

ENAMEL (ENAMELLING)

A process of applying vitreous substances of various colours to metallic or porcelain surfaces. Objects decorated by this process are called 'enamels.' The technique dates back to ancient times; the Egyptians, Greeks, Romans, and ancient Orientals, used the art to embellish their jewellery. The technique reached its peak of perfection in Byzantium between the ninth and eleventh

centuries, and gradually spread across Europe. In the fifteenth and sixteenth centuries the chief centres of enamelling were Lorraine and Limoges. During this period the technique of painting pictures in enamel on copper without the use of cloisons (metal fences: see *Cloisonné*) to hold the vitreous pastes was perfected by Italian and French enamellers.

ENCAUSTIC

From the Greek for 'burnt in.' Painting executed by a process of 'burning in,' with vehicles in which wax is the chief ingredient. A technique practised by the Egyptians, Greeks and Romans, in which pigments are mixed with molten wax and applied to the painting surface with warmed instruments.

ENGRAVING

The art of drawing on wood, metal, etc. by a process of incising lines. See *Drypoint, Etching, Line Engraving, Wood-Engraving*.

ENTABLATURE

The upper part of an architectural order, consisting of architrave, frieze and cornice.

ENTASIS

The slight swelling in the shaft of a column, introduced to correct the visual illusion of concaving in the sides when several columns are used together.

ESQUISSE

French expression for a preliminary outline or sketch.

ETCHING

A method of engraving a metal plate, such as zinc, copper or steel, by a process of biting the drawn lines with

mordants. The design is first drawn into a wax ground with an etching needle, and then subjected to a series of acid bitings. Finally the plate is inked, wiped and printed.

ETRUSCAN ART

The tomb painting, sculpture, pottery and bronze-ware produced by the people of Etruria in Northern Italy around the sixth century B.C. Strongly influenced by the Greeks, the Etruscan civilization and culture were eventually absorbed into the Roman Empire.

EXPRESSIONISM

Emotionalism. Any kind of art in which the personal emotions of the artist are predominantly important, as for instance in the paintings of El Greco (1545–1614) and Van Gogh (1853–90). In the modern sense Expressionism originated in northern Europe with the Norwegian Edvard Munch (1863–1944). He had much influence in Germany where in 1905 the *Die Brücke* (The Bridge) Group was founded in Dresden. Later, in 1911, a second Expressionist Group was founded in Munich and called *Der Blaue Reiter* (The Blue Rider). Among the Expressionist painters associated with these groups were Nolde, Kokoschka, Marc, Kandinsky and Schmidt-Rottluff.

EX-VOTO

A painted or sculptured image designed to give thanks to God for favours and blessings, or to ask for existing needs. The retablos of Latin America are one example.

EYE LEVEL or EYE LINE

In perspective, the line ahead of the spectator which is level with his horizontal line of sight. It is on this line that parallel lines converge to meet at vanishing points. Also known as the Horizon Line.

F

FAIENCE

A term derived from the name of the Italian town, Faenza, and used to describe glazed earthenware and porcelain of all kinds.

'FAT OVER LEAN'

A traditional rule. The principle of painting fat colour over lean applies in all cases where there is to be any overpainting, of any sort, on the basis of an underpainting. In the case of an oil ground (priming) the superimposed painting should be richer in oil than the ground. The rule might also be expressed as 'start lean and finish fat.'

FAUVISM
(From Fauves—Fr. 'Wild Beasts.')

The name first used contemptuously of a group of French painters who exhibited their work at the Salon d'Automne in 1905. They were so called because of their violent, uncontrolled use of brilliant colour. The leader of this group was Henri Matisse, and among the followers of Fauvism were Rouault, Vlaminck, Derain and Dufy.

FAYUM PORTRAIT

Intensely realistic portraits of deceased persons painted by the artists of Fayum, a province of Egypt, usually on mummy cases. The portraits belong to the first four centuries of the Christian era, and were painted in *Encaustic* (see above) on wood, and sometimes directly onto the linen shroud of the deceased.

FÊTE CHAMPÊTRE

A painting of rural festivities, e.g. 'The Dance of the Peasants' by Pieter Brueghel.

FÊTE GALANTE

A painting of a convivial and elegant festive occasion. Antoine Watteau is a master of the 'fête galante.'

FIGURINE

A small modelled or sculptural figure.

FINE ARTS

Those arts which in certain circumstances need possess no practical function, and which are measurable purely in relation to their aesthetic significance. In the broadest sense however the term includes architecture, painting, sculpture, poetry and music, but is usually applied to

painting, sculpture and architecture, the latter being traditionally regarded as more than the science of building and as a major form of aesthetic expression. As opposed to applied art, where function is at least as important as aesthetic significance. (See *Applied Art*.)

FIXATIVE

A solution which can be sprayed onto drawings rendered in pencils, chalks, and various other impermanent and easily removed materials, so as to fix them, and prevent smudging.

FLAMBÉ

In pottery, the irregular application of the glaze, usually by splashing, in order to produce a desired effect.

FORESHORTENING

The apparent shortening of forms in relation to the angle from which they are observed. The appearance of shortening becomes more acute as the angle between the eye-line and the nearest point of the form, e.g. an outstretched arm, is reduced.

FOLK ART

The pictures, pottery, sculpture, etc., produced by untrained artists of humble stock. E.g. the work of the American natural painters and colonial limners (see *Limner*) many of them anonymous. Today, the pottery and small scale ceramic figure-work produced by peasant or rural societies.

FORE-EDGE PAINTING

The painting of a decoration or design on the front (occasionally the top) edge of a book.

FORM

The structural element(s) in a work of art whereby the artist's conception and vision is given a tangible form. This can vary from the purely representational, or realistic, to the purely abstract.

FORMALISM

In art, the representation of the formal aspects of a subject, irrespective of its subject content.

FOXING

A discoloration of the leaves of books, engravings, etc. appearing in the form of brownish spots.

FOXY COLOUR

Colour in a painting which is over-hot in hue.

FRESCO

The art of painting on freshly spread plaster while it is still wet. Called more specifically *Buon Fresco*, or True Fresco. In modern parlance less correctly, the term for painting on plaster in any manner.

FRESCO SECCO

A process similar in principle to that of Buon Fresco, except that the plaster is allowed to dry before the pigments are applied. Less permanent than True Fresco.

FRET

An ornament in Classic and Renaissance architecture consisting of an assemblage of straight lines intersecting at right angles, and of various patterns.

FROTTAGE

A technique invented by the Surrealist, Max Ernst. The process consists of taking rubbings from various surfaces, such as wood, stone, etc.

FUGITIVE PIGMENTS

Pigments which are particularly susceptible to the following factors:—
(a) The action of light which might cause them to fade.
(b) The action of various atmospheric impurities.
(c) The action of a vehicle or medium.
(d) The action of pigments with which they have been mixed.

FUTURISM

Dynamic painting as opposed to the static qualities of Cubism. The Italian Futurist movement was launched in 1909, when the poet Marinetti published the Futurist literary manifesto. The principal theme of the Manifesto, to which the painters subsequently subscribed, was that of absolute opposition to the art of the past (Le Passé-isme, as Marinetti called it) and the glorification of the present. The first 'Manifesto of the Futurist Painters' was proclaimed at Turin in 1910. It was signed by Boccioni, Carrà, Russolo, Balla, and Severini. The general intentions of the futurist movement are expressed in this sentence from the manifesto, 'Action, in our works will no longer be an arrested moment of universal Dynamism. It will be, simply, Dynamic Sensation itself.' In their painting they endeavoured to paint dynamic and simultaneous action: 'A galloping horse has not four legs; it has twenty, and their movements are triangular.'

G

GALVANISTIC COPY

A forgery of a medal, plaquette, or statue—usually of bronze—effected by an electrolytical process.

GANOSIS

A classical (Greek) method of polishing the surfaces of statues, and the interiors of temples. The process consisted of first preparing the surface with a layer of thin plaster, then painting on this with pigments mixed with a medium which was probably size and finally, when dry, of 'polishing with candles' (Pliny).

GARGOYLE

A spout, usually in the form of a grotesque animal or human head, with open mouth, projecting from the gut-

ter of a building to carry water clear of the wall. Commonly found in Gothic building.

GENRE

The portrayal of scenes or anecdotes from everyday life, such as the domestic, humorous, and tavern scenes in Dutch seventeenth century painting.

GESSO

Plaster of Paris or gypsum. When prepared with a proportion of glue, water, etc. gesso provides a ground for wood panels (or less usually canvas) preparatory to painting. Or chalk, glue and white.

GESAMTKUNSTWERK

The 'universal work of art.' The theory that, irrespective of date, place of origin, or type, there are certain fundamental laws and characteristics common to *all* great art.

GESTALT

The psychology of the character of perception. An expression introduced in 1890 by the German psychologist, Christian Ehrenfels, to indicate the character of perception as a unity. Thus, the seeing of a square does not consist in seeing four equal straight lines enclosing four right angles, but is the perception of the square as a whole. Likewise, in aesthetics, the apprehension and appreciation of the work of art depends upon total perception physical, psychological, and metaphysical. In the sense of Gestalt therefore, the work of art cannot be apprehended in terms of its parts, but only as a unity.

GILDING

The art of covering substances, such as wood, with layers of gold leaf.

GLAZE

A transparent, or semi-transparent film of colour, applied over a light ground or a lighter colour (which must be thoroughly dry).

GLUEWORMS

The cracks in a chalk priming due to the presence of too much glue.

GOLDEN PAINTING

An alternative name for *Translucid Painting* (q.v.).

GOLDEN SECTION

A geometrical proportion which has for centuries been regarded as a universal law governing the harmony of proportions both in art and in nature. The proportion is formulated in two propositions of Euclid; Book II, proposition 11 ('To cut a given straight line so that the rectangle is equal to the square in the remaining segment') and Book VI, proposition 30 ('To cut a given finite line in extreme and mean ratio'). But the common formula is 'To cut a finite line so that the shorter part is to the longer part as the longer part is to the whole.' Use is frequently made of the Golden Section to arrive at the right proportions between length and breadth in the rectangles made by doors, windows, the pages of books, etc. The proportion is often applied in painting, e.g. the relationship of the amount of space above the horizon line to the amount of space below.

GOTHIC

Term applied to the style of architecture, painting and sculpture which flourished in France and England mainly, between the 12th and 16th century. In architecture the Gothic style includes Early English, Decorated and Perpendicular.

GOTHIC REVIVAL

The revival of interest in the 'Gothic style' which began early in the 19th century and exercised great influence on architectural taste during the Victorian period.

GOUACHE

A method of painting with opaque colours which have been ground in water and tempered with a preparation of gum.

More generally, a term used to describe a method of water colour painting in which white is employed as a pigment, by contrast with the method of attaining whites by allowing the paper to show through.

Broadly speaking, the difference between Gouache and Water Colour painting, is simply that Gouache is water colour tempered with white and used *opaquely*, and water colour is used without white and *transparently*.

GRADATED COLOUR

A passage of colour which gradually changes its hue, chroma and/or value.

GRAFFITO

The last plaster coat of a fresco ground which is coloured before application.

GRAND STYLE or GRAND MANNER

Term used, e.g. by Sir Joshua Reynolds, to define the Renaissance ideal in art, i.e. representation of the human figure in elevated themes. Earlier, Nicolas Poussin, a master of the grand manner, said that the style consists of four elements: 'subject-matter or theme, thought, structure, and style.'

GRAPHIC ARTS

Those forms of pictorial expression which are linear in character, such as drawing, all forms of engraving, etc. Also used to describe the best products of printing and typography.

GRISAILLE

A monochrome painting of a bas-relief in black and white and their mixtures (neutral greys).

GROTESCHI

An architectural medley or *Capriccio* (see above).

GROTESQUE PAINTING

Paintings of grotesque subjects such as monsters, demons, or macabre fancies. A form of imaginative genre.

GROUND

The surface applied to a canvas or other support, upon which a picture is painted. A coating of a material suitable to receive and hold pigments.

GYPSUM

Plaster of Paris (see *Gesso*).

H

'HALF CLOSED EYES'

The practice of looking at a subject with half closed eyes, so as to reduce the obtrusiveness of detail, and enable the painter to resolve its appearance into simple masses of light and dark.

HALF-TONE

The tone value in a painting which is halfway between the dark and the light. Sometimes called Middle-Tone.

HATCHING

A system of building up the tones or shadows in a drawing or a painting by applying the pencil, chalk, or pigment in a series of lines, often crossing one another

(cross-hatching) at various angles. Sometimes called *Tratteggiare*.

HELLENISTIC
The term used to describe the later and more emotive phase of ancient Greek art (300–100 B.C.) as distinct from the qualities characteristic of the classical or Hellenic period (600–300 B.C.). Hence Hellenic, Hellenistic.

HIDING POWER
A property of opaque pigments; the power to 'hide' the ground painted over.

HIGHLIGHT
The locality of any surface which catches the most light.

HIGH RENAISSANCE
Approximately, the period from about 1500 to the death of Michelangelo in 1564 when the art forms of the Renaissance (which had developed in the course of the 15th century) reached their highest degree of comparative perfection.

HISTORY PAINTING
Term used in the 18th and 19th centuries to denote pictures with subjects taken either from Greek and Roman or from Biblical history.

HORIZON LINE
An alternative term for *Eye Level* or *Eye Line* (see above).

HOT COLOUR
Colour which is too red, or fiery.

HUE
See *Colour*.

HUMANISM

The practise of the arts, etc. in relation to such humanistic ideas as the importance, and potential, of man as an individual; a belief in the power of learning and science to produce the 'complete man'; the desire to enlarge the bounds of learning and knowledge; the growth of scepticism and free thinking.

Modern Humanism originated in the Renaissance when scholars, writers, poets, philosophers, scientists sought regeneration in the freer intellectual spirit of Classical times.

In northern Europe it is also associated with the Reformation and the rejection of the Medieval Church. Thus the Humanism of the Renaissance caused religious subjects in art to be replaced or supplemented by portraiture, and the subjects of classical mythology.

I

ICHNOGRAPHY

(*a*) The art of drawing with architectural and mechanical instruments.

(*b*) The art of tracing.

ICON

An Eastern Church image, painting, or mosaic of a sacred personage, regarded as sacred in itself.

ICONOGRAPHY

The language of symbols, images, and pictures. The representation of abstract ideas and concepts through a system of symbolic imagery. Thus we can speak of the iconography of Egyptian or Byzantine art. Also the

symbolic meaning of the figures or forms within a given painting.

IDEALIZATION

A form of aesthetic distortion which consists of the representation of things according to a preconception of an ideal form, type. The human type evolved in Greek Sculpture, and Leonardo's spiritualized female type, such as the Madonna and Angel in the 'Virgin of the Rocks' (National Gallery, London, and Louvre Gallery, Paris) are examples of aesthetic idealization.

IKONOSTASIS

A painting on a screen to hide an altar.

ILLUMINATION

Painting on vellum or parchment which acts as an adornment for the accompanying manuscript. The effect is often heightened by the use of gold leaf.

ILLUSIONISM

The practice of *Trompe L'Oeil* (q.v.) painting.

IMPASTO

A particularly thick or heavy application of paint. It is the contrast of impasted areas with thinly painted passages which often imparts character and robustness to an oil painting, e.g. the thickly painted highlights and thinly painted shadow areas in many of Rembrandt's paintings.

IMPRESSIONISM

The movement which originated in the 1860's and is usually considered to mark the beginning of the modern movement in art. The Impressionists were the first group of painters to impart a new direction to the traditions of representing landscape. The leaders of the movement

included Monet, Pissarro, Guillaumin, Renoir, Sisley, Cézanne, and later, Seurat and Signac (see Pointillism). Impressionist theory was based on two main principles; (a) the attempt to capture a fleeting, atmospheric *impression* of nature, as though seen for the first time, and in relation to the constantly changing circumstances of 'light.' The Impressionists insisted on the importance of painting 'on the spot' as opposed to the tradition of working in the studio from notes, sketches and memory. (b) the employment of the spectrum range of colours, these being, scientifically the only ones consistent with the theory that 'light' is primarily important, and that the painter should therefore use only those hues which are to be found by the spectroscopic analysis of 'light.' (The splitting up of light in the prism.) Black and brown were omitted from the Impressionist palette. The starting point of the movement was the *Salon des Refusés* Exhibition of 1863 (q.v.) and the term 'Impressionism' was first used abusively by a critic to describe Monet's painting 'Sunrise: an Impression' which was shown at the first group exhibition in 1874.

IMPRIMATURA
A coloured under-tint, frequently laid over an outline.

INDUSTRIAL ART OR INDUSTRIAL DESIGN
Distinct from *Applied Art* (see above) and consisting in the endeavour to find the most appropriate forms for objects of use produced by machines.

INFRA-RED PHOTOGRAPHY
Fulfills the same function as *X-Radiography* (q.v.) in the examination of painting.

INTAGLIO
An engraved design hollowed out and thus the opposite of Relief. It is applied to engraved gems and also to the

reproductive processes of wood or metal engraving, or etching, where prints are taken from an incised surface.

INTARSIA

A technique of decoration in which designs are created by cutting up various materials such as mother-of-pearl, metal, ivory, slices of coloured marble, etc., and applying them to a wooden surface or, in the case of marble, to a wall. Inlay.

INTERMEDIATE VARNISH

An Intermediate Varnish serves to moisten the dry layer of an underpainting and facilitates the principle that in oil painting (unless a painting is completed alla prima) it is advantageous to paint 'wet into wet.'

INTIMISM

The painting of intimate scenes, e.g. domestic interiors or objects associated with them. A type of genre practised particularly by French painters like Edgar Degas (1834–1917), Pierre Bonnard (1867–1947), Edouard Vuillard (1868–1940) and by the English painter, Walter Sickert (1860–1942).

INTONACO

The final coat of plaster applied to a wall preparatory to the commencement of a fresco painting. The actual painting ground for fresco.

ISOCEPHALY

A style of composition characteristic of the Classical period—especially in relation to Greek art—in which the figures in a composition are so arranged that they are all of the same height; as for instance in a frieze.

ITALIAN PRIMITIVISM

The unsophisticated art of the early Italian painters was considered 'primitive' in relation to the sophisticated development culminating in the Renaissance. The art of the 13th, 14th and 15th century Schools of Florence and Siena.

K

KEY
An alternative term for *Wedge* (q.v.).

L

'L'ART POUR L'ART'

Literally, 'Art for Art's Sake.' A French expression which first gained currency in the 1840's and reflected the desire of poets and painters to emphasise the importance and independence of their work in face of bourgeois hostility. It became a watchword of the *Aesthetic Movement* (see above).

L'ART RUPESTRE

A term used to describe all those types of art which are drawn, painted, or incised on rocks, in caves or rock shelters, by pre-historic and primitive races.

LAY FIGURÉ

Jointed wooden figure of human body, used by painters and sculptors on which to arrange drapery. Usually

life-size and more elaborately jointed than the *Manikin* (q.v.).

LEAN COLOUR

Pigment containing, or used with, a minimum of oil.

LEAN SURFACE

The matt surface of a layer of pigment containing a minimum of oil. It is essential that an underpainting which is to be glazed should possess a lean surface.

LIFE-ENHANCEMENT

According to Bernard Berenson, the primary function and role of art—the power to enhance, enrich, and extend the meaning of life; 'There are various kinds of life-enhancement. The one we are most concerned with in this place, is derived from the feeling of higher potency, fuller capacity, greater competence, due to the sense of unexpected ease in the exercise of our functions, induced by the arts of visual representation.' Elsewhere, speaking of the attainment of life-enhancement through the act of Empathy (see above) Berenson speaks of it as 'the ideated plunging into a state of being, or state of mind, that makes one feel more hopefully, more zestfully alive; reaching out to the topmost peak of our capacities, contented with no satisfaction lower than the highest.'

LIMNER(S)

The anonymous portrait painters of the American colonial period were called 'limners,' a name which derives perhaps from the word 'illuminate.' These untutored artists practised portrait painting as a side-line to their main occupations of wagon painting, sign-writing, etc.

LINEAR PERSPECTIVE

The art of delineating solid objects on a plane surface by the exercise of the science of *Perspective* (q.v.).

LINE ENGRAVING

A method of engraving in which the line is incised directly into the plate with a Graver, or Burin, and the 'burr' (see above) removed, so that a clean, sharp, metallic line can be printed.

LINING

An alternative term for *Relining* (q.v.).

LITERARY ART

An alternative term for Narrative Art (see *Narrative Painting*).

LITHOGRAPHY

A method of reproduction in which a drawing is made on a lithographic stone or a prepared zinc plate with a greasy crayon, or ink, and prints taken. For colour Lithography, separate drawings are required for each colour.

LOADED BRUSH

A brush which is loaded with pigment ready for the application of a thick, heavy impasto.

LOCAL COLOUR

Theoretically, the positive colour of an object, etc. unmodified by the colour of other things or the prevailing circumstances of atmosphere, lighting, viewpoint, the proximity of other colours, and so on. In fact it has no exact existence, since all colour is subject to the conditions in which it is seen.

LOCKING-UP

In oil painting, the sealing up of fugitive pigments in a varnish, or special oil, to preserve them.

LOW TONE

Subdued colour or tone.

LUCE DI SOTTO ('LIGHT FROM BENEATH')

The luminosity of an undercolour which can be seen through an over-glaze.

LUMINISM

An alternative, seldom used, name for *Impressionism*.

LUMINOSITY

In relation to any sort of painting, the reflection of light from a white ground, through transparent pigments so as to give brilliance and luminosity to the completed work.

LUNETTE

A painting which fills a semi-circle, or a segment of a circle; such as a crescent-shaped or semi-circular space in a dome or ceiling. In architecture, a semi-circular window.

M

MAGIC REALISM

A form of naturalistic painting charged with emotional tension and practised by twentieth century painters like the Italians Chirico and Carrà (see *Metaphysical Painting*) and the New Objectivity painters of Germany like Otto Dix (see *Verism*). In America, practised by such men as Peter Bloom, Alton Pickens and Andrew Wyeth.

MAGOT

A contemptuous term for the figures in porcelain, ivory, etc. produced in China and Japan during the nineteenth century to meet the uncritical European taste for *Chinoiserie* (see above).

MAHL-STICK

A long stick, padded at one end, on which a painter can rest his hand to steady it when working.

MAÎTRE POPULAIRE

The French expression for *Sunday Painter* (q.v.).

MAJESTY

A religious painting which represents the Father and the Son, and sometimes the Virgin as well.

MAJOLICA

A type of enamelled pottery, said to have been first made in Majorca. The term is especially applicable to the richly decorated enamel pottery at one time produced in Italy, and is also used to describe modern imitations of this type of pottery.

MAKIMONO

A Japanese or Chinese painting wound on rollers.

MALERISCH

A German term for the 'painterly values' involved in technique and *Matière* (q.v.) as distinct from aesthetic, psychological and other abstract values.

MANDORLA

A type of picture portraying the Virgin and Child in which the Child is shown in a Mandorla (almond shape) affixed to, but not inside the body of the Mother.

MANIKIN

Artist's lay figure, or anatomical model of the body. A small jointed figure of the same proportions as the human figure. They appear at least as early as the sixteenth century.

MANNERISM

Originally the term implied a mannered or superficial imitation of a great creative style, lacking in originality or deep feeling. Now used to define a period of originality and diversity which followed on the heels of the high Renaissance in Italy and lasted through the rest of the 16th century. It is possible to see in Michelangelo's *Last Judgment* a point of departure. For the mannerist school grew out of a revolt against the calm perfection of Raphael's classicism and was stimulated by the restless and expressive turmoil of Michelangelo's great fresco. Mannerist work is easily identifiable, and it is mainly characterised by an emphasis on the human figure set in theatrical and strained or contorted poses, by exaggerated musculature and facial expression, and by groupings and lighting effects all of which together heighten the emotional character of the work. Color, too, plays its part in obtaining strong and disturbing effects. Major proponents of the movement: Pontormo, Rosso, Parmigianiro; and later, Bronzino, Tintoretto, El Greco.

MAQUETTE

A rough miniature model used by sculptors as a guide for a larger finished work.

MARIOLA

A painting of the Virgin.

MARQUETRY

The craft of inlaying wood with other woods of varying colours, or with other materials, such as tortoise-shell, ivory, metal, mother-of-pearl, etc. to make pictures or designs.

MASCHERONE

A painted or sculptural mask.

MASS

In painting, any large form, or group of forms, or any substantial area of colour, light, shade, etc. The excellence of composition depends very largely on the skillful organisation of mass and space. In composition mass is considered to be the positive element, and space the negative element.

MATIÈRE

An expression used when referring to the intrinsic qualities of the physical surface of a painting, irrespective of subject content.

MATT SURFACE

A dull, flat surface, without gloss or sheen.

MEDIUM

In a general sense, the particular material with which a picture is executed; oils, water colour, chalks, pen and ink, etc. It may also refer to the liquid with which powdered pigments are ground to make paint, and in a more restricted sense, to the liquid used to render paint more fluid and workable.

METAPHYSICAL ART

In the modern sense, a style of painting established—and later abandoned—by Giorgio de Chirico who with Carlo Carrà launched the *Scuola Metafisica* in 1917. The philosophy and aims of contemporary metaphysical painting are expressed in a statement of Chirico's dated 1919:—'Everything has two aspects; the current aspect, which we see nearly always and which ordinary men

see, and the ghostly and metaphysical aspect, which only rare individuals may see in moments of clairvoyance and metaphysical abstraction. A work of art must narrate something that does not appear within its outline. The objects and figures represented in it must likewise poetically tell you of something that is far away from them, and also of what their shapes materially hide from us.' Metaphysical art can be related to that branch of philosophy—Metaphysics—which is concerned with the ultimate nature of reality. Broadly speaking, any form of art which is based on incorporeal, super-natural, or visionary sources of inspiration. Thus in poetry Richard Crashaw (1613–49) and in literature and painting William Blake (1757–1827) are types of the creative metaphysician. Another contemporary artist to practise Metaphysical Painting was the Italian Carlo Carrà (1881–).

MÉTIER

The particular subject in which an artist specialises.

MEZZOTINT

A method of engraving in tone, commonly practised in the eighteenth century. A metal plate, usually copper or steel, is roughened by means of a rocking tool which makes indentions and raises a 'burr.' The burr is scraped away where lighter tones are wanted in the design. The process was widely used for the reproduction of works by such artists as Reynolds, Romney, Lawrence, Turner and many others.

MICRO-CHEMICAL ANALYSIS

The microscopic examination of the physical materials of a painting, such as type of ground, pigment, oil, varnish, etc. with a view to the determination of age, authenticity, etc.

MIDDLE DISTANCE

In landscape, the plane which exists between the foreground and the background.

MIDDLE TONE

In painting, the hue of a tonal value which is half-way between the respective tonal values of light and dark. Sometimes called Half-Tone, or Middle-Tone.

MILDEW

One of the diseases to which oil paintings are prone: common to pictures which have been varnished with mastic varnish and confined in a close room.

MINIATURE PAINTING

Small scale painting, usually portraiture, such as that practised by the English miniaturists of the sixteenth century, notably Nicholas Hilliard (c. 1547–1619), miniaturist and goldsmith to Queen Elizabeth.

MIXED METHOD OR MIXED TECHNIQUE

A method of painting practised, for example, by Jan Van Eyck and early Flemish painters which consists of completing a tempera underpainting with a series of oil glazes.

MOBILE

A light, abstract construction, usually suspended from the ceiling as a form of decoration. Mobiles have the property of movement and are sensitive to gentle breezes or currents of warm air. The American, Alexander Calder, is a leading exponent of this art.

MOCK DRAPERY

A method of decorating a wall by means of paintings representing drapery, whether modelled and realistic, or conventionalized and flat.

MODELLING

The technical process of representing form in any medium, pencil, chalk, pigment, clay, etc.

MODELLO

An accurate, small-scale sketch, for a proposed larger work.

MODERN PRIMITIVISM (MODERN PRIMITIVES)

The simple, unsophisticated, naïve vision and style of untutored modern artists like Henri (Douanier) Rousseau, Camille Bombois, Morris Hirshfield, and Grandma Moses.

MONOCHROME

A painting in one colour. Underpaintings are usually in monochrome.

MONOTYPE

A method of taking prints from a painting made on a sheet of glass, or metal. The method consists of laying a sheet of paper over the image and rubbing an impression while the paint is still wet, or tacky. Although a number of prints can be taken from the same plate, each is likely to be unique.

MORBIDEZZA

An Italian expression for the life-like representation of flesh-tints.

MORDANT

In etching, the acid used for the purpose of biting the lines drawn by an etching needle.

In gilding, the sticky vehicle which is applied to a surface that is to be gilded.

MOSAIC

Designs or pictures formed by the juxtaposition of small cubes of glass, stone, marble, etc. A technique much employed in Roman times for floor and wall decorations, and extensively used by Byzantine artists to picture the story of Christianity. The mosaics at S. Sophia, Constantinople, and notably the Church of St. Vitale at Ravenna are among the outstanding examples of the technique.

MOTIF

The dominant feature, or idea, in a composition, or design.

MUDDINESS

Muddiness results when too many colours are mixed together.

MURAL PAINTING

A decorative picture which is painted on a wall, or fastened to a wall surface.

N

NABIS

From the Hebrew word meaning a prophet. Chief theorist and leader of the movement which was founded in the 1890's was the painter Maurice Denis (1870–1943). Other members of the group included Felix Vallaton, Edouard Vuillard, and Pierre Bonnard. The aim of the Nabis—or prophets—was to charge the simple scenes of everyday life with a pervading sense of the mystical otherness of familiar, homely things. E.g. the mystical quality of a lamplit room. Related to Intimism. Bonnard and Vuillard are called Intimists.

NARRATIVE PAINTING (OR NARRATIVE ART)

That sort of painting which is primarily concerned with the telling of stories. Painting in which the story is more

important than the method of its execution, or any aesthetic considerations. The chief characteristic of much Victorian painting, for instance.

NATURALISM

The precise image of an object in nature, true to life in every detail, photographic—such as the painting of the Dutch Little Masters. Differs from *realism* which represents life in a broad sense, as in the work of Courbet.

NATURE MORTE

French expression for 'still life.'

NEO-CLASSICISM

The reaction against the sensuous, romantic art of the French Court which followed the Revolution, and was inspired by classical models. The leader of the movement was the painter Jacques Louis David (1748–1825) an ardent Republican supporter. Other Neo-Classical painters included Ingres (1780–1867) and Prud'hon (1758–1823). In sculpture Canova (1757–1821) and Thorwaldsen (1770–1844) represent a similar aim.

NEO-GOTHIC

An alternative expression for *Gothic Revival* (see above).

NEO-IMPRESSIONISM

The form of Impressionism developed by Georges Seurat (1859–1891) and Paul Signac (1863–1935) and more usually called *Pointillism* (q.v.).

NEO-PLASTICISM

An alternative term for *De Stijl* (see above).

NEO-ROMANTICISM

The prevailing spirit of a school of modern British painters with strong affinities and roots in the work of

such artists as Edward Calvert (1799–1883) and Samuel Palmer (1805–1881). The leaders of the group included Paul Nash, Graham Sutherland, John Piper and John Minton. Their approach consists of an imaginative, romantic interpretation of nature.

NEUTRAL COLOUR
A colour which has no positive hue.

NEW OBJECTIVITY PAINTING
See *Verism*.

NIMBUS
Gold disc, or circle of light, round or over the head of a sacred personage in a painting.

NON-OBJECTIVE ART
This is an umbrella term covering such styles in modern art as abstract expressionism, geometric expressionism, action painting, constructivism, *tachisme*. Kandinsky is held to be the father of the movement. Basically a method of using color, line, texture and purely abstract (non-recognizable) shapes and forms to eliminate reality in either painting or sculpture. Some leading proponents, after Kandinsky: Pollock, Gorky, Mondrian, Gabo, Pevsner, Calder. See also Suprematism.

NORTH LIGHT
The light which is usually considered to be the best in which to paint since it is least liable to change. Hence the demand for studios with a north light.

OBELISK

Four sided monolithic shaft of stone with pyramidal apex, e.g. 'Cleopatra's Needle,' Victoria Embankment, London.

OBJECTIVE PAINTING

Painting which is based, so far as this is ever possible, on the objective world of physical actuality; on the objective existence of natural phenomena. Such painting usually tends towards some form of realism (naturalism).

ODALISQUE

A female slave or concubine in an Oriental harem. A popular subject with painters like Ingres (1780–1867), Renoir (1841–1919) and Matisse (1869–1954).

OIL COLOUR

Paint which is produced by grinding pigments with an oil; such as linseed or poppy oil.

OILING OUT

A process of rubbing a drying oil, such as linseed, or poppy oil, over those colours in a painting which have 'sunk in' and consequently lost their lustre. The immediate effect of such a process is to restore the brilliance and lustre of the colours, so that further touches can be added. But final effect is ultimate darkness.

OPACITY

Non-transparency in certain pigments. The characteristic of pigments which reflect the light from their surface, but do not transmit it to the surface below.

OPTICAL MIXING

Theoretically, the mixing of juxtaposed colours by the eye. Thus, when seen at the correct distance red and yellow, for instance, produce on the retina, the sensation of orange (see *Pointillism*).

ORMOLU

The gilded bronze used in decorating furniture; gold-coloured alloy of copper, zinc, tin. A term used to describe articles made, or decorated in this way.

ORPHISM

The title given by Guillaume Apollinaire, the French poet, to a movement started by the painter Robert Delaunay in 1911. Delaunay based his art on the idea of the harmonious, abstract organisation of pure colours. He renounced objects, depth and perspective to delight in his profoundly sensuous passion for colour. He sought a universe of colour, arguing that, 'colour alone is both

form and subject.' His study of pure colours suggested to him a variety of special rhythms reacting to certain contrasts, and these became celebrated as his 'simultaneous contrasts.' He compared them to the alternation of happiness and unhappiness in the emotions of love. Although Delaunay was unaware of Eugène Chevreul's famous 'Laws of the Simultaneous Contrasts of Colour' at the time he invented Orphism, the essentials of the two theories are remarkably comparable. Among the original adherents of the movement were three American artists, Patrick Bruce, Morgan Russell and S. Macdonald Wright. Sometimes called Colour Orchestration or *Synchronism*.

OUTLINE
An alternative term for *Contour* (see above).

OVERPAINTING
A layer of pigment which is applied over an underpainting.

P

PALETTE

A word which refers not only to the surface on which an artist sets out, and mixes his pigments, but also to the range of colours which he uses. The term can also be used to describe the typical colour range of a school or group, e.g. we talk of 'the Palette of the Impressionists' (The Spectrum Palette), 'the restricted Palette' of the painters of ancient Greece (generally speaking, white, black, yellow ochre and a red earth) and so on.

PALIOTTO PAINTING

The painting on an altar-piece. Also known as *Dossale* painting.

PALMESEL

A picture of Christ riding on an ass. In the past such pictures were mounted on wheels and drawn through the streets on Palm Sunday.

PANEL PAINTING

A painting on wood, or some other hard surface such as metal (e.g. copper). Wood panels were in common use among European artists during the whole of the middle ages. Canvas was not in general use until the close of the fifteenth century.

PANNEAU DÉCORATIF

A decorative panel.

PANORAMA

A continuous painting round the walls of a circular room. The panorama is said to have been invented by the Scottish painter, Richard Barker, in 1788. The term can also be applied to any picture which portrays an extensive view, or prospect.

PAPIERS COLLÉS

From the French meaning 'pasted papers.' The making of pictures and designs from pieces of coloured paper, cardboard, newsprint, playing cards, etc., which are cut into various shapes, and stuck onto sheets of paper. The technique was first practised as an art form by the Cubists Picasso, Braque and Gris. *Collage* (q.v.).

PARERGON

An ornament or decoration which is not essential to the main subject of a painting. The term is sometimes used to describe the incidental fragments of landscape in the background to portraits, or figure compositions.

PARQUETING

A method of reinforcing the backs of wood panels with battens, to prevent them from warping.

PASSAGE

A metaphorical term, used when referring to a certain part, or area of a painting. Also used to describe the transition from one tone to another, by means of a half-tone.

PASTEL PAINTING

The term used to describe a picture which has been rendered with pastels—i.e. dry pigments.

PASTICCIO

An alternative term for *Pastiche* (see below).

PASTICHE

A work of art composed in the style of another person.

PASTOSE

Thick brushwork.

PATTERN

A decorative design, such as that executed on carpets, wallpapers, textiles, etc.

PATINA

The incrustation, usually green, on the surface of old, or ancient bronzes, often esteemed as a form of enhancement.

PEEP-SHOW

A painting, usually of an interior, carried out on the inside of three sides of a box and viewed through a

small hole in the fourth side. Fashionable among Dutch painters during the seventeenth century.

PELLICLE

The thin skin, or film which forms as oil pigment dries.

PENSIERO

An alternative term for a *Sketch* (q.v.).

PERMANENT PIGMENTS

Pigments in which the susceptibility to deteriorate under certain atmospheric conditions (see *Fugitive Pigments*) has been reduced to a minimum. Artists' colourmen usually classify these 'Permanent' pigments, although the term is purely relative.

PERPENDICULAR STYLE

The last phase of English Gothic architecture, following the Decorated period, and preceding the Italianate style of the early English Renaissance of the 16th century. The Perpendicular style is notable for its slender, vertical, ascending lines, and for the elaboration of ornament.

PERSPECTIVE

A scientific method employed by artists (dating from the Renaissance; Piero Della Francesca (1416?–1492), wrote a book on perspective) as an aid to the delineation of solid objects on a plane surface, so as to give the same impression of relative positions, magnitudes, distances, etc. as the actual objects do when viewed from a particular point.

PÉTARD

A term sometimes used to describe a picture which has been painted to attract attention by its deliberate oddity.

A painting in which the colour is extravagant, and artificially brilliant.

PETITE NATURE
A term used to describe those figures in a painting which are between full and half-size.

PIECE-MOULD CASTING
In sculpture, a method of casting a clay original in various sections.

PIETÀ
A picture or sculpture depicting the Virgin mourning over the dead body of Christ.

PIGMENTS
The colouring substances, usually in powder form, which are mixed or ground with the liquids called vehicles to form paint.

PIGMENTS; THEIR CLASSIFICATION
Broadly speaking, Pigments may be divided into two main groups, *MINERAL* and *ORGANIC*, according to their source of origin. *Mineral pigments* are those which are natural, such as earth colours obtained by mining, and those which are artificially produced, by methods such as high temperature firing, like cobalt blue, viridian, and cadmium scarlet. *Organic pigments* are those derived from animal and vegetable sources, such as Indian yellow and the madders, and certain artificial pigments, like Prussian blue. Pigments can also be classified in relation to their physical and chemical characteristics, such as those which are opaque and transparent, permanent and fugitive.

PITTURA TRANSLUCIDA

An alternative term for Golden, or *Translucid Painting* (q.v.).

PLAFOND PAINTING

A painting on a ceiling.

PLAGIARISM

In art, the lifeless imitation of an original style.

PLANE SURFACE

A level surface, picture or plane, such as a canvas. The two-dimensional surface upon which the painter can create the illusion of other dimensions, such as volume and space.

PLASTIC ARTS

The arts of moulding, and modelling, such as pottery, and sculpture (especially modelling in clay). The term plastic is also used of any effort to reproduce three-dimensional form, including painting.

PLATYTERA

An alternative term for *Mandorla* (see above).

'PLEIN AIR'
('In the open Air' and 'Out of doors')

An expression used to describe the practice of painting in the open, in order to study and describe effects of light and atmosphere. A practise pioneered by the French painters of the Barbizon School, and continued by Monet and other Impressionists.

PLUMBAGO

Black lead. A sulphate of iron used in the manufacture of lead pencils, and varying in degrees of softness.

PLUMB LINE

A line, such as a piece of string, with a weight at one end, used by draughtsmen and painters as a mechanical aid in representing the figure. Of particular use in plotting the balance of a standing pose.

POCHADE BOX

A small portable colour-box with panels fitted into the lid for quick sketching. This type of colour-box, which was first used by the early water-colour painters (the English masters of the 18th and 19th centuries) now holds materials for oil painting.

POINTILLISM

From the French, pointiller, meaning, to dot, stipple. A system of late Impressionist painting developed by the second generation of French Impressionists whose leaders were Georges Seurat (1859–1891) and Paul Signac (1863–1935). Contrary to the practice of colour mixing on the palette, pointillism consists of applying separated spots, or dots, of pure colour, side by side on the canvas, e.g. red and yellow for orange, red and blue for mauve, and so on. Theoretically, at the right distance, the spectator's eye automatically mixes the colours. See *Optical Mixing*. The system is also known as *Divisionism*.

POLYPTYCH

A picture, usually an altar-piece, in the form of more than three leaves hinged together.

POSTER COLOUR

An opaque water colour (gouache) obtainable in pots or tubes; often used by poster designers.

POUNCING

A method of tracing the outlines of a cartoon or drawing onto a wall, canvas or panel. Holes are pricked with a pin, or needle, along the outlines of the cartoon, which is then placed over the painting surface. Powdered chalk in a muslin bag is then dabbed, or 'pounced' over the surface of the cartoon; the powdered chalk penetrates the perforations, so transferring the outlines of the design to the painting ground.

POWDER COLOUR

An opaque water colour (gouache) in powder form. When mixed with water it forms a creamy paste similar to poster colour.

PRE-COLUMBIAN ART

The art of the Americas before the coming of Spanish and other settlers. The term covers the North American Indian as well as such civilizations as the Aztecs and Mayas. In South America Pre-Columbian art is chiefly Peruvian, the last culture before the arrival of the Spaniards being that of the Incas.

PREDELLA

The vertical face of the altar-step, or the raised shelf at the back of the altar, often decorated with a frieze of painting or sculpture.

PREHISTORIC ART

The painting and sculpture produced by artists of the Old, Middle, and New Stone Ages (see Cave Painting). The earliest known piece of prehistoric sculpture is the famous Venus of Willendorf (Natural History Museum, Vienna), a small fertility image of Palaeolithic origin dating around 11,000 B.C.

PRE-RAPHAELITISM

A movement founded in 1848 by Dante Gabriel Rossetti (1828–82), John Everett Millais (1829–96) and Holman Hunt (1827–1910). First known as the Pre-Raphaelite Brotherhood (P.R.B.). Theoretically, the Pre-Raphaelites aimed at the abandonment of the scientific spirit of the Renaissance, especially as exemplified in the work of Raphael, and strove to recapture the simple faith and vision of the late medieval religious painters, particularly that of the Italian primitives. The group broke up in the early 1850's, although the spirit of Pre-Raphaelitism continued to exert an influence on certain individuals, notably on Hunt himself, and Sir Edward Burne-Jones (1833–98). Its later outcome was the craftsmanship of William Morris (1834–96) inspired by that of the Middle Ages.

PRIMARY COLOURS

The master colours, red, yellow and blue, from which with the addition of white, it is possible to mix the full spectrum range; red, orange, yellow, green, blue, indigo, and violet.

PRIMING

The layer of white lead or zinc and linseed oil which is applied to the support—wood, canvas, etc.—after the pores have been sealed with a coating of size. Less commonly, any preparation, such as size and whiting, size and plaster of Paris, casein and whiting, which is used to prepare the support for the reception of the pigment.

PRIMITIVE ART

The art of primitive societies, whether prehistoric, or later, such as the art of Africa, Oceania, and the ab-

original art of Australia. Also the simple, naïve vision and style of untutored artists like Henri Rousseau and Grandma Moses. See *Modern Primitives:* also *Italian Primitives.*

PRIMITIVISM

The naïve, simple, childlike vision and style that is characteristic of certain modern painters, e.g. Henri Douanier Rousseau and Grandma Moses, or the art of primitive societies, and the early Italian Schools.

PRINT

Name for etching, lithograph, woodcut, etc.

PSYCHO-PRISMATISM (PRISMATOLOGY)

The study of the reactions of human beings and animals to the various colours. The psychology of affective reaction to colour.

PURE COLOUR

A hue which is unadulterated by admixture with another.

PURISM

A movement in modern painting and sculpture, founded in 1918 by the painters, Amédée Ozenfant, Le Corbusier, and Brancusi. Purism was a reaction against the analytical spirit of Cubism and sought to remake, and thus purify, the world of objects, etc. that Cubism had broken into fragments. The philosophy of Purism was expounded in the Purist Manifesto—*Après le Cubisme* —published in 1918. The Purists felt that Cubism had reached a dead end and degenerated into a mere decorative formula. 'A beautiful subject never hurt anyone,' wrote Ozenfant. He painted purist compositions mainly of still life, in clear, cold colours.

PUTTI

The figures of nude cupid-like infants in Italian Renaissance painting and sculpture.

PYRAMIDAL COMPOSITION

A type of Composition common to Italian religious painting, reaching perfection in many of Raphael's Madonnas. It bases the organisation of a central group, such as a Madonna and Child, on the shape of a pyramid, with, in this instance the head as apex, and the arms, etc. set at angles of about 30 degrees from the verticals of the canvas. Sometimes called triangular composition. Examples of this type of composition include Raphael's Madonna del Cardellino (Uffizi), The Madonna of the Meadow (Vienna, Museum), The Canigiani Madonna (Munich, Pinakothek) and The Sistine Madonna (Dresden, Gallery).

Q

QUATTROCENTO
The fifteenth century in Italian art.

R

RAYONNISM

A form of Abstract painting created by the Russian artist Michel Larinov in 1909. His Rayonnist Manifesto was published in 1913. The aim of Rayonnism was the creation of forms by the radiation of colours. Probably the most important of Larinov's Rayonnist principles was the following:—'Here begins a type of painting which can only succeed if it follows precise laws of colour and of their transposition onto canvas. Here begins the creation of new forms whose meaning and whose force depend solely on their tonal strength and their position in relation to other tones.'

REALISM

Fidelity to natural appearances, without slavish attention to minute details, observable in many periods of Euro-

pean art, but to be distinguished as a movement in the 1840's in France. Realism then rejected both ideal ('classical') and imaginative subject matter and became closely associated with the study of contemporary life (Courbet and Manet). Impressionism may be looked on as the final phase of realism, in which, however, contemporary life became of less importance than the realistic rendering of light and atmosphere.

RECESSION

The sense, or illusion of depth into a *Plane Surface* (see above).

REDUCING GLASS

A lens which reduces the size of a large-scale drawing, painting, or design, so that the artist can study its appearance for reproduction, etc. Also called a diminishing glass.

REFLECTED COLOUR

Colour which is reflected into the hue of an object, etc. from an extraneous source. This phenomenon is virtually a condition of the nature of seeing colour, since strictly speaking, there is no such thing as local colour (hue). See *Local Colour*.

REFLECTED LIGHT(S)

Those lights in objects, etc. which are collected from a secondary source of illumination, such as a mirror.

RELIEF

Moulding, carving, or stamping, in which the subject stands out, or projects from the plane of the background. The degree of projection is variable, e.g. Alto-Relievo, Basso-Relievo.

RELINING (OR LINING)

The affixing of a painting onto a new canvas. This consists of fastening to the back of the original canvas another piece, large enough to give a margin sufficient for restretching.

RENAISSANCE

The new direction given to learning and letters, architecture, sculpture and painting from the 14th century onwards, beginning in and best illustrated by Italy. At first a revival (literally 'rebirth') of Greek and Roman models in literature, architecture and sculpture, it developed into an ardent desire for knowledge and the awareness of human dignity and power which attained its height in the visual arts with Michelangelo, Raphael and Leonardo da Vinci. The humanistic spirit and style of the Renaissance spread from Italy to other European countries.

REPOUSSÉ

Ornamental metal work in which the decoration is hammered into relief from the reverse side.

REPRESENTATIONAL ART

That kind of painting or sculpture which tries, so far as possible, to reproduce the physical appearance of objects, persons, or other subjects. As distinct from non-representational art where the interest in surface appearances is of little or no account.

REREDOS

An ornamental screen covering the wall at the back of the altar of a church.

RETABLE

The frame enclosing the decorative panels at the back of an altar.

RETOUCHING

Or repainting. An ill-advised and dangerous method of restoring and painting by over-working.

RETREATING COLOUR

A colour, such as blue, which in a painting appears to retreat into the distance. The assumption is based on the theory that objects tend to become colder in hue as they become more distant.

RITRATTO

A portrait.

ROCAILLE

The French for Rococo (see below).

ROCOCO

From the French, *rocaille,* meaning pebble, or rock work of the kind used to decorate artificial grottoes. The reason for the use of the word Rococo (as in the case of the word *Baroque*) remains a mystery. The free, flowing, profuse and often confused style of decoration and ornament, especially in relation to interior design, prevalent in Europe during the period circa 1700–80. The style, delicate version, or extension of the Baroque, though it was decorative and not propagandist in purpose. (A lighter form of Baroque?) It originated during the reign of Louis XIV, and was continued notably under Louis XV. It is usually considered that the style reaches perfection in the German versions of Rococo. Sir Banister

Fletcher writes of the rock-like forms, fantastic scrolls, and crimped shells, worked together in a profusion and confusion of detail, often without organic coherence, but presenting a lavish display of decoration, which is characteristic of the Rococo style. Sir Herbert Read classifies Rococo as 'the last manifestation in Europe of an original style.'

ROMANESQUE

The style of architecture, sculpture and painting based on Roman prototypes, prevalent in Western Europe from the ninth to the twelfth century. The style varies from one country to another, but the rounded arch in architecture is a common denominator. Norman architecture is the English Romanesque. In pictorial art, the severe and simple style of religious painting which complemented the architecture of the period. In sculpture the tympani of Vezelay and of St. Trophime.

ROMANTICISM

The term used to describe that kind of art in which imagination plays the predominant role. The opposite of Classicism (see above). In painting it is especially used of the movement which flourished in France about 1830, as a reaction against the severe dictates of the Neo-Classical School founded by J. L. David. The leaders of the Romantic movement were Géricault (1791–1824) and Eugène Delacroix (1798–1863) who found some inspiration in the literary Romanticism of England and Germany.

RONDO

A circular picture.

ROUGHCAST

The first coat of plaster applied to a wall to prepare it for Fresco painting. The roughcast must be rough so that the succeeding plaster coats can get a hold on it.

ROUGHING IN

The preliminary 'lay-in' of the main masses of light and dark in a picture. An underpainting.

S

SALON

Annual exhibitions of painting and sculpture in France, e.g. the Paris Salon.

'SALON DES REFUSÉS'

The starting point of the Impressionist movement. It was here, in 1863, that such artists as Monet primarily, and the Impressionists Pissarro, Cézanne, and Guillaumin, exhibited the work which had been rejected by the official salon.

SANGUINE

Red chalk. A favourite medium of many old master draughtsmen.

SANTA CONVERSAZIONE

A religious conversation-piece, depicting saintly person-
ages, usually in a pleasant landscape setting.

SCALING

One of the diseases to which oil paintings are prone.
The chief causes of scaling are: (a) Excess of size in the
priming, (b) The careless mixture of pigments, (c) Rolling
or folding a canvas, (d) The use of too much varnish.

'SCHOOL OF'

A covering term used by authorities to indicate that a
work in the style of a master was produced by a painter
who worked under his influence, and followed his ideas,
conventions, and technical methods. Thus a painting
from the 'School of' a master is less closely related to
him than a work in his manner which could be classified
as *Studio of* (q.v.).

SCUMBLE

The reverse of a Glaze. A film of opaque pigment
applied over a darker colour to lighten it.

SEICENTO

The seventeenth century in Italian art.

SFREGAZZI

A method of glazing shadows over flesh colours which
is accomplished by dragging a finger carrying the
colour over the area to be shaded.

SFUMATEZZA

The blending of colours.

SFUMATO

The soft blending of light tones into dark. Leonardo da Vinci is one of the great exponents of this practice.

'SGRAFFITO' (GRAFFITO)

A method of mural decoration in which a dark surface which has been covered by a coat of lighter colour is made to reappear in the form of lines, or stripes, by scratching away the light coloured overpainting.

SHADE

The dark degree of a hue.

SICCATIVE (OR DRIER)

A preparation used to hasten the drying of paints. Substance added to a drying oil to increase its rate of drying in the air. The use of siccatives or driers is a dangerous practise which is liable to lead to cracking.

SIGNIFICANT FORM

A term invented by Clive Bell to account for the hypothetical 'universal element' which, according to certain authorities, is common to all great art, irrespective of the time and place of origin. It can also mean the significance of the aesthetic form of the work of art, irrespective of subject content. Thus Roger Fry writes, 'No one who has a real understanding of the art of painting attaches any importance to what we call—"the subject of a picture"—what is represented.'

SILHOUETTE

After Étienne de Silhouette (1709–67) a French Finance Minister. A portrait of a person in profile, all inside the outline being usually black. Such portraits are set against a white ground, and are sometimes cut from a black, or dark paper.

SILK SCREEN

A method of colour reproduction, often used commercially for the reproduction of posters, etc. The system consists of breaking up the design or picture to be reproduced into its chief colours, for each of which a silk frame is prepared. These represent the different colours and the shape of the areas which each colour is to cover. Paint is then squeezed through the respective screens onto the printing paper.

SILVER-POINT

A method of drawing which consists of working with a silver tipped instrument on a specially prepared paper. The result is a drawing of great delicacy. Generally used by late medieval and Renaissance artists, e.g. Leonardo da Vinci.

SINGERIE

A painting in which monkeys are represented in various human roles.

SINKING-IN

Sometimes referred to as *Embu*. During the process of painting, and after completion, oil pigments are likely to 'sink-in,' so that the painting becomes dull, lifeless and matt, either in parts or throughout.

SKETCH

A rapid drawing or painting, which may be complete in itself, or intended as a preliminary draft, or idea, for a more detailed project. Alternatively called a modello, pensiero, sprezzatura, etc.

SKIN
The leathery film formed from linseed oil when it has dried in the air.

SLIP
The semi-fluid clay which is used for coating earthenware.

SOCIAL REALISM
A movement which originated in America in the 1920's and reached its peak during the great depression of the thirties. It was critical of all forms of 'art-for-art's sake,' anti-romantic, and primarily concerned with commenting critically on the social, economic, and political problems of the day. E.g. the poverty and despair of the unemployed masses, and their aspirations towards the achievement of a better life.

SOLID PAINTING
A painting executed with thick *Impasto*.

SOLVENT
A substance, such as benzine, alcohol, etc., which has the property of dissolving other substances. In relation to painting, a paint remover of pigments and varnish. Solvents of various kinds are used by the picture restorer.

'SOUL PAINTING'
A Romantic term for *Expressionism* (see above).

SPALLIERE PAINTING
A decorative painting on the back of a chair.

SPECTRUM PALETTE

The range of colours first used by French Impressionists, (see *Impressionism*) and restricted to those of the spectrum viz. red, orange, yellow, green, blue, indigo and violet.

SPREZZATURA

An alternative term for a *Sketch* (see above).

SQUARING OR SQUARING UP

A method of transferring a small, preparatory sketch, or drawing, to a larger working surface, such as a wall, or canvas. The process is based on the division of both surfaces into a series of numbered proportionate squares.

STABILE

A light abstract construction of wire, wood, etc., used as a static decoration; as opposed to *Mobile* (see above).

STAINED GLASS

The art of cutting coloured glass into various shapes, joined by lead strips to form a pictorial window design. The technique was in widespread use during the medieval and Gothic periods. E.g. the stained glass in the Cathedrals of Canterbury, Winchester, Chartres, Rouen, Cologne, etc. The art probably originated in the Near East around the ninth century.

STAND-OIL

The preparation which results from the boiling of linseed oil, with the exclusion of air. It was probably this type of oil that was used by Jan Van Eyck (1385?–1441) and the painters of the Flemish School.

STATUARY

A term used in Tudor times to describe a whole-length portrait. Later as the equivalent of figure sculpture.

STEREOCHROMY

A comparatively new method of mural painting, in which water-glass is used both as a vehicle and protective coating.

STILL LIFE

A subject for a painting composed of inanimate objects, e.g. fruit, flowers, dead fish, game, etc. Fr: *Nature Morte* (dead nature).

STIPPLING

A method of painting by means of small dots, or touches of colour (see *Pointillism*).

STRIATION

The rendering of drapery by a series of stripes or lines. A method of rendering drapery common in Byzantine mosaics and painting, and carried on by the painters of the Trecento.

'STUDIO OF'

A covering term used by authorities to indicate that in the light of all known circumstances, a work in the style of a master was in all probability produced in his studio—or workshop—that he was responsible for its conception, the supervision of its execution, and that he may have done a limited amount of work on it.

STUDY

A careful, preliminary drawing, or painting, for a proposed work; a careful drawing, or painting for a detail of a proposed work.

STYLE

An artist's characteristic manner of expression. It may apply more generally to the characteristic manner of a period of art.

STYLIZATION

Conformity with the rules of a conventional style. In art, a tendency towards the academic. Not original.

SUBJECTIVE PAINTING

That type of painting, such as *Expressionism,* and *Surrealism,* which is chiefly conditioned by the character of the artist's personal psychology. Painting which is subjectively rather than objectively inspired.

SUITE

A series of paintings linked by a common theme, such as Hogarth's 'Marriage à la Mode,' 'The Rake's Progress,' etc.

SUNDAY PAINTER

An amateur artist who paints solely for pleasure.

SUPER-REALISM

An alternative term for *Surrealism* (q.v.).

SUPPORT

The untreated material to which, after the application of a suitable ground, paint will be applied. This material may be wood, canvas, cardboard, metal, paper, a wall, etc.

SUPREMATISM

Suprematism was created in Moscow in 1913, by the painter, Kasimir Malevich. In that year he exhibited a picture of a black square on a white ground, to demon-

strate his principle of 'a system of absolutely pure geometrical abstraction.' Malevich's theories were published by the Bauhaus in 1927 under the title of 'The Non-Objective World.' Malevich wrote: 1. 'By Suprematism, I mean the supremacy of pure feeling in the pictorial arts.' 2. 'When in 1913, in a desperate attempt to rid art of the ballast of objectivity, I took refuge in the form of the square, and exhibited a picture that represented nothing more than a black square on a white field, the critics—and with them society—sighed, "All that we loved has been lost. We are in a desert. Before us stands a black square on a white ground" . . . But the desert is filled with the spirit of non-objective feeling which penetrates everything.' 3. 'For the Suprematist, the proper means is the one that provides the fullest expression of pure feeling and ignores the habitually accepted object. The object in itself is meaningless to him; and the ideas of the conscious mind are worthless. Feeling is the decisive factor . . . and thus art arrives at non-objective representation—at Suprematism.'

SURREALISM

From the French meaning 'super-reality'; the *other reality* of the unconscious, of the dreams, fantasies, and imaginings which comprise the major part of psychological personality. The term 'surrealism' was invented by the writer Apollinaire to designate the movement officially launched in 1924 when a group of writers and painters under the leadership of André Breton published the first Surrealist Manifesto. 'Everywhere the soul of man is in chains,' claimed the document; henceforth it would be the task of the artist to liberate man's unconscious personality from the chains of reason and inhibition. The movement was profoundly influenced by the psychological and psycho-analytical theories of Freud and, with its insistence on the uninhibited, unselective representation of dreams and fantasies, upon the prac-

109

tice of automatic writing and drawing, and in its attempts to use the free association technique of psycho-analytical practice, Surrealist painting and writing was soon to become largely a pictorial province of Freudian theory. The leading exponents of the Surrealist movement included Salvador Dali, Giorgio de Chirico, Max Ernst, and Yves Tanguy.

SYMBOLISM

In art, the expression of an abstract idea in terms of line, form, colour, etc. The representation of an object by means of a single, formal equivalent, as in cave art, or the imagery of Byzantine art. In the Freudian sense, Symbolism is extensively employed in Surrealist painting. The use of symbols to imply abstract ideas, e.g. the sexual symbolism employed by Salvador Dali; the medieval symbolistic iconography used by Hieronymus Bosch.

SYMMETRY

Beauty resulting from aesthetic balance. The harmonious organisation of subject content; the balancing of one shape, or form, etc., with one similar. The converse of *Asymmetry* (see above).

SYNCHRONISM

An alternative expression for *Orphism* (see above).

SYNTHETIC CUBISM

The second stage in the practice of Cubism (see *Cubism*); the imaginative reorganization of basic elements, and the consequent creation of new forms, planes and dimensions, extracted from the themes of the familiar world, and often presented in a unique space. In the years that followed the 1914–18 War, Fernand Léger invented a space without perspective in which he

set his geometrized elements, reintroducing at the same time, a more colourful and less austere range of hues than appears in the earlier Cubism. His work of the period, approximately 1918–23, in which he was often preoccupied with the organisation of dynamic machine-like forms, might be considered the final, and most fruitful offerings of Synthetic Cubism.

SYNTHETISM (SYMBOLISM)

A movement founded in 1888 and led by Gauguin and the painter Emile Bernard, both of whom recognized the need for an aesthetic language that could be bent and moulded to the service of the painter's ideas. The objective of the Synthetist painter was to construct a synthesis of the real and the imaginary and so bring into existence a language of personal symbolism.

T

TABLE

An alternative term for a cabinet—or easel-picture. (See *Easel-picture* above).

TACHISME

From the French to stain, spot, blot. An extreme form of *action painting* (see above) in which the artist relies entirely upon the creation of accidental patterns, textures, etc., not only by the action of splashing, slapping, or dribbling paint onto a surface, but by such methods as setting fire to sheets of cardboard covered with bituminous paint and paraffin (the British painter William Green is an exponent of this method), the uncontrolled trickling of water colour, riding a bicycle over

wet paint, or the employment of other means, no matter how extravagant, in the search for fortuitous effects.

TACTILE VALUES

In relation to the work of art, the *total* experience, both physical and imaginative of apprehending and enjoying a painting; the awareness of distance, space, and mass; of warmth and coolness, stillness and noise, etc. Berenson describes tactile values thus; 'Tactile values occur in representations of solid objects when communicated, not as mere reproductions (no matter how veracious), but in a way that stirs the imagination to feel their bulk, heft their weight, realise their potential resistance, span their distance from us, and encourage us, always imaginatively, to come into close touch with, to grasp, to embrace, or to walk around them.'

TECHNIQUE

Technical skill. In art the mechanical mastery of methods and materials.

TEMPERA

A method of painting in which the pigments (ground in water) are mixed or tempered with an emulsion, or the yolk or white of eggs.

TEMPERING

The mixing of pigments.

TENEBROSI (TENEBRISTS)

A group of early 17th century painters, inspired by Caravaggio (c. 1569–1609) who painted interior scenes, often lit by candle or torch-light and providing sharp contrasts of light and dark. Georges de Latour (1593–1652) was the great French Tenebrist.

TERRACOTTA

Hard, unglazed, literally 'baked earth' pottery of a brownish-red colour. A material used by sculptors in making small figures; also used for architectural ornaments.

TESSELLATED

Formed of tesserae, such as a tessellated pavement.

TESSERAE

The small cubes of glass, marble, stone, etc. used in the execution of mosaic.

TEXTURE

In painting: (a) the representation of the physical characteristics of any particular surface (skin, fabric, wood, metal, earth, etc.) (b) the characteristics of the paint surface itself; whether smooth, rough, etc.

THROWING

In pottery, the term used to describe the technical process of creating a pot, vase, dish, etc. on the potter's wheel. Thus the expression 'throwing a pot,' etc.

TIMPANO

The painted cover which used to protect certain types of painting from atmospheric, and other injuries.

TINT. (Also TEINTE or TINCTUS)

The light degree of a hue.

TOBIOLO

A picture portraying the story of Tobit. This was a favourite subject with the Italian painters of the Quattrocento.

TONDO

Painting or sculptured relief of oval or circular form.

TONE

In the general sense, a term used to describe the 'complexion' of a painting; e.g. 'the golden tone of Venetian painting'; 'the subdued tone of Rembrandt'; 'the bright tone of Impressionism.' More specifically, a synonym for 'value' used when the tonal values of a painting are under discussion or consideration.

TONED GROUND

A ground which has been tinted.

TONING

The process of colouring an oil painting by tinting the monochrome underpainting with glazes and scumbles.

TOOTH

The roughness, or grain of the support.

TOPOGRAPHICAL PAINTING

A faithful and detailed representation of a particular place. A pictorial description of the natural and artificial features of a town, village, district, etc.

TORMENTED COLOUR

Colour which has been mixed, or manipulated to excess. Such colours are prone to blackening. Also known as 'Drowned Colour.'

TRANSITIONAL

In architecture, the change of style from Norman to Early English.

TRANSLUCID PAINTING
A method of painting first practised about the twelfth century, which consists of painting with thinned oil colours, over a metal foil surface. Also known as Golden Painting.

TRANSPARENT PAINTING
Painting with transparent pigments as opposed to opaque ones, e.g. glazing, water colour painting. Transparent pigment is converted into opaque pigment by the addition of white.

TRATTEGGIARE
An alternative term for *Hatching* (see above).

TRECENTO
The fourteenth century in Italian art.

TRIAD
A group of three colours harmoniously related to each other.

TRIANGULAR COMPOSITION
An alternative term for *pyramidal composition* (see above).

TRICHROMATIC PALETTE
The primaries, consisting of yellow, blue, and red, from which it is theoretically possible to mix all the other colours of the spectrum.

TRIPTYCH
A painting in the form of three leaves or panels, hinged together. E.g. The Garden of Earthly Delights, altarpiece of Hieronymus Bosch, The Prado, Madrid.

TROMPE L'OEIL

A painting which creates the illusion of actually being what it sets out to depict. E.g. a drop of water on a rose petal, an insect crawling over a flower-stem which looks as though it could be brushed off the canvas. Literally, to deceive the eye. A piece of technical trickery not to be confused with Realism.

TRUCAGE

The forgery of painting.

TRUQUEUR

One who practises *Trucage*—a forger.

U

ULTRA-VIOLET LIGHT
Fulfils the same function as *X-Radiography* (q.v.) in the
examination of painting.

UNDERPAINTING
See *Abbozzo*.

UNDER-TINT
See *Imprimatura*.

UNITY OF COLOUR
See *Colour Unity*.

V

VANISHING POINT

In *Perspective*, the point on the horizon line at which parallel lines appear to vanish.

VEDUTA

A painting of a view of a city.

VEGETABLE DRYING OILS

An oil, such as linseed oil, which when exposed to the air combines with oxygen to form a transparent, leathery film (Linoxyn). It is this property which makes it so useful in painting.

VEHICLE

Strictly speaking, the liquid—such as linseed oil—with which prepared pigments are mixed, to render them less stiff, and more workable. The term is sometimes used to describe the liquid with which powdered pigments are ground during the process of preparing oil paints; although in this case the liquid is more usually called 'the medium.'

VELARE SYSTEM

Velare: An Italian term for a thin veil or film of colour. A process of painting in *Glazes* or *Scumbles*, over an *Underpainting*.

VERDACCIO

A neutral tint for outlining a design on a canvas or panel. Recommended by Cennino Cennini (late 14th century) as an underpainting tint; composed of a mixture of black, white, yellow and red ochres.

VERISM

A form of representational *Expressionism* (see above) in which the emphasis is upon clinical detail and intensity of psychological mood. Often related to repellent subject matter. E.g. the art of the German painter Otto Dix (1891–). Also called New Objectivity Painting.

VESPERBILD

A German term for a painting which portrays the Virgin holding the dead Christ on her knees.

VEXIERBILD

A German term for a puzzle picture.

120

VIERGE OUVRANTE

A hollow statuette of the Virgin and Child which can be opened in front, like a triptych, to reveal the passion of Christ. A few genuine examples exist. E.g. a restored ivory figure in the Cathedral Treasury at Evora, Portugal.

VIGNETTE

In architecture, an ornament of leaves and tendrils. The flourishes around the capital letter in MSS. An engraved book illustration not enclosed by any definite border. A portrait showing only the head and shoulders, with the background gradually shaded off.

VORTICISM

An English equivalent of the Italian Futurist movement. Vorticism was founded by Wyndham Lewis and originally subscribed to by writers and artists like Ezra Pound, Gaudier-Brzeska, and Jacob Epstein. The term Vorticism derives from the sub-title of Lewis' journal *Blast;* 'A review of the Great-English Vortex.' The first number was published in June, 1914. The programme of the movement was to free English art from the errors of the past and set up a genuine 20th century art, the vortex being the point of 'maximum energy.' The aim of Vorticism was to bring all forms of art into line with the machine, and the spirit of the machine age (the cult of the machine). *Blast* sponsored this new spirit which was in violent reaction against the aestheticism of the 'nineties,' and the cult and philosophy of 'art for art's sake.'

W

WARM COLOURS

Colours of a warm hue, such as yellow, which appear opposite cool colours, such as blue, and violet, on a colour circle.

WARPING

A distortion of wood panels due especially to the absorption of excessive moisture.

WASH

A thin, transparent film of water colour, usually applied over a relatively large area of the paper; thus the expression, 'laying a wash.' The word can also be used to describe a type of drawing, such as 'pen and wash,' in

which the main areas of shadow are applied in washes of dark water colour.

WATER COLOUR

In the general sense, pigment which has been mixed with gum as a binder. The term used to describe that form of transparent water painting in which the white of the paper furnishes the lights, and in which no white pigment is used during the execution of a picture.

The technique of pure water colour painting reached its highest perfection in England during the latter part of the eighteenth—and the first half of the nineteenth century. On the Continent, where white pigment is frequently mixed with transparent pigments (see *Gouache*) pure water colour painting is known as 'the English method.'

WEDGES

The small triangular wooden keys which are driven into the mitred corners of a chassis after the canvas has been stretched, and preferably primed. They are primarily intended for later use in tightening up a canvas which has become slack. This is done by tapping the wedges with a hammer.

WERKSTATT

A German term for workshop or studio and by association for a painting which comes from the Studio, or School of a Master. (See *Studio, School,* above.)

WHITE GROUND

In the late eighteenth century, a group of English painters, of whom Sir Thomas Lawrence (1769–1830) was the central figure, returned to the traditional practice of working on a white ground and using transparent pigments. The method gave brilliance and luminosity to

their work. R. P. Bonington (1801–28) also applied the same method in his landscape painting. This brilliance and luminosity became known on the continent as the *chic anglais,* and was the subject of much admiration.

WHOLE LENGTH
A portrait of the complete figure.

WOODCUT
Method of taking a print from the surface of a wood block, the parts not to be printed being cut away.

WOOD ENGRAVING
A method of incising a drawing or design on a wooden block from which a print can be taken.

X

X-RADIOGRAPHY

A method of examining the construction of a painting, by taking X-ray photographs. By this method of analysis it is possible to study the various stages in the production of a painting; the type of underpainting, corrections, etc. The method is particularly useful in helping to understand how the old masters worked. It is also of use for the detection of forgery.

Y

YELLOWING

The discoloration of an oil painting, the chief causes of which are: the excessive use of oil as a vehicle; the use of certain siccatives, and pigments; glazing, varnishing, damp and darkness.